Denise L. Stone

Using the Art Museum

Davis Publications, Inc., Worcester, Massachusetts

ART EDUCATION IN PRACTICE SERIES

Marilyn G. Stewart

Editor

Denise L. Stone

Using the Art Museum

Series Preface

Follow an art teacher around for a day—and then stand amazed. At any given moment, the art teacher has a ready knowledge of materials available for making and responding to art; lesson plans with objectives for student learning; resources for extending art learning to other subjects; and the capabilities, interests, and needs of the students in the art room. Working with a schedule that sometimes requires shifting several times a day from working with students in preschool to those in elementary, middle, and high school, the art teacher decides what to teach, how to teach it, whether students have learned it, and what to do next. The need for rapid decision making in the artroom is relentless.

The demands continue after school as the art teacher engages in assessment of student learning, curriculum planning, organization of materials, and a wide range of activities within the school community. Although most teachers want to be aware of and to integrate into their teaching new findings and developments within their field, they are pressed to find the time for routine, extensive reading of the literature.

Art Education in Practice provides the art teacher, museum educator, student, scholar, and layperson involved in art education with an overview of significant topics in art education theory and practice. The series is designed to meet the needs of art educators who want to know the issues within, the rationales provided for, and the practical implications of accepting curricular proposals presented from a variety of scholarly and political perspectives.

The emphasis of the series is on informed practice. Each text focuses on a topic that has received considerable attention in art education literature and advocacy statements, but one that has not always been accompanied by clear, concise, and accessible recommendations for the classroom. As new issues arise, books will be added to the series. The goal of the series is to complement the professional libraries of practitioners in the field of art education and, in turn, enhance the art-related lives of their students.

Editor's Introduction

I sometimes teach an art criticism course to registered nurses, as part of a Bachelor of Science in Nursing program. We typically meet at the hospital where they spend their workdays, but as part of the course we also make several trips to local museums. I am routinely struck by the fact that only a handful of students have entered these institutions. When questioned about past museum experiences, they speak generally of a lack of meaning in field trips that were part of their K–12 education. Those who have visited museums as adults describe their level of discomfort during these visits. They talk of being overwhelmed by their lack of knowledge about works of art, and of uncertainty in navigating the institution. Sadly, they see little connection between their own daily lives and the life of institutions in their own community.

I suspect that the nurses' encounters are similar to those of many adults whose careers are outside the arts. This is particularly troubling when we consider that one important goal of art education is to prepare students for lifelong joy and meaning derived from repeated experiences with the arts. The confidence and inclination to view and interpret artworks can be encouraged through substantive classroom experiences in which students learn perceptual and interpretive skills. Art educators also can assist students in discovering where and how they might continue to engage with artworks as they emerge from formal schooling.

A museum field trip partially addresses this goal in many art programs. In the best cases, the art specialist, in concert with museum educators, plans such trips as an integral part of the art curriculum. For a variety of reasons, however, museum visits are often isolated events with little or no art program connec-

tion. Scheduling museum field trips, for instance, might be the purview of central administration, with certain grade levels targeted and visits planned according to a master schedule. When art teachers are released from their regular duties to accompany their students, they may or may not assist in planning the content of the visit. In other cases, also for a variety of reasons, museum field trips are simply not possible.

Denise Stone considers the museum as a viable resource for art teachers who take seriously the hope that students will continue their engagement with art well into adulthood. Drawing upon her extensive research in this area, the author provides readers with an overview of the history of museums, information about their common structure and mission, and numerous examples of programs in which students are engaged in substantive ways. For art teachers who are involved in planning museum field trips, she provides practical guidance in designing meaningful visits.

Stone details strategies for making the purpose and function of museums come alive, even for students who will not visit the museum. She also considers other possible venues, such as local history museums and the Internet, for extending and enriching the study of art. This book is filled with teaching tips and resources. The author's understanding of the day-to-day workings of school art programs will resonate with readers seeking a resource that is both theoretically sound and well-grounded in art education practice.

Marilyn G. Stewart

Publisher: Wyatt Wade
Editor in Chief: Helen Ronan
Production Editor: Carol Harley
Manufacturing: Georgiana Rock, April Dawley
Copyeditor: Kevin Supples
Design: Jeannet Leendertse

Library of Congress Catalog Card Number: 2001089524
ISBN: 87192-464-1
10 9 8 7 6 5 4 3 2 1
Printed in the United States of America

Acknowledgments

A book such as this is not realized without the generosity of colleagues and friends. There are many professionals who have given their time, comments, and words of encouragement. Their contributions have been invaluable.

In conceptualizing my ideas and writing, I was greatly assisted by my excellent colleague Elizabeth Kowalchuk, who tirelessly read and reread drafts of chapters. Her numerous insightful suggestions energized my thinking and progress. Good friends and colleagues in art museum education were critical to my understanding of museums and the role of education in these institutions. I wish to express my deepest gratitude to Anne El-Omami, who over the years has shared her expertise and perspective of the museum world. Her incisive comments were both a source of important information and inspiration. To Ray Williams, a heartfelt thanks for patience and guidance during the early implementation of my research. His perceptive ideas about art museum education helped me to develop and direct this project.

Museum educators who freely shared their knowledge, support, and materials include Susan Hazelroth, Allison Perkins, Barbara Bassett, Peggy Burchenal, Gretchen Deitrich, and Libby Cluett. I also wish to acknowledge the numerous art and history museum educators and professionals who willingly talked to me about their collections, educational programs, and work with teachers. It would be impossible to write a useful book for the artroom without the expert help of teachers. Art educators who generously reviewed early drafts of book chapters were Angelia Perkins and Sheila Wilkins. Their candid comments helped me think realistically about the museum in art education.

Many classroom and art teachers also discussed their museum experiences and how they related field trips to their curriculum. I am especially grateful to Elizabeth Hatchett, Larry Percy, Joyce Huser, and others for their help, time, and advice.

My appreciation goes to Marilyn Stewart for her enthusiasm for the project. The realization of this book represents an important step in furthering relationships between art museums and schools. Marilyn's perspective assisted me in diminishing the gap between the practical and the abstract. Finally, I wish to thank Rita Napier. She has been unwavering in her support, and generous in her reviews of various chapters. Her counsel and ideas were crucial throughout the project.

Denise L. Stone

Table of Contents

Chapter *3*

Chapter *4*

Chapter *5*

Chapter 6

Chapter 7

1

The Art Museum as a Resource

"[The museum] is probably our richest cultural resource. It brings to our community some of the best artists and the best artwork. And kids don't have to see it in books; they can actually see it in person and walk around it."[1]

—Carole Debuse, art teacher, South High School, Omaha, Nebraska

Collecting is a basic human tendency; it spans the history of humankind and appears in many cultures. People acquire all kinds of things, from buttons and antique furniture to dolls and jewelry. And they collect for many reasons. We may desire to own a certain type of object—for example, pottery—because we love its diversity of colors, textures, and forms. Or we might obtain some things, such as coins or stamps, to learn more about their history. People also collect items for rituals, whether religious, communal, or personal; or, our motives may be sentimental or superstitious. And, a collection can remind us of faraway places, loved ones, important experiences, and even ideas. The human interest in collecting is as varied as the diversity of cultural values throughout the world.

Organizing and Displaying Collections

Accumulating a collection often leads to a desire to organize it or to somehow keep track of its pieces. A large collection may even necessitate the creation of a list or catalogue. Related to this process of organization is one of maintenance; certain collections may require special care or constant upkeep.

Collecting also leads to curiosity about the objects, and this can be an impetus for questioning and research. In turn this may spur a continuous process of learning, which for some collectors becomes a lifelong passion. Collecting may even lead to the development of expert knowledge in a particular area. Such knowledge may then provide the basis for improved or more finely tuned methods of organization and an increased understanding and appreciation of the importance of proper maintenance. As you can see, the ramifications of collecting can quickly multiply.

Related to the collecting process is a basic desire to display one's collection. Acquiring often inspires a wish to allow others to admire the objects that we find interesting or beautiful, and that we have invested time and effort to learn about, organize, and maintain. We might create a simple display of a collection so that it is visible and accessible to ourselves as well as to family members and friends. Or we may devise elaborate showcases that emphasize certain qualities and connections or that reveal our collection's significance in a meaningful way. Such displays can also be an invitation or means to discuss a collection with visitors and fellow collectors.

1.1 Frank Gehry, Guggenheim Museum, *1997. Bilbao, Spain. Photo © Lynn Simon.*

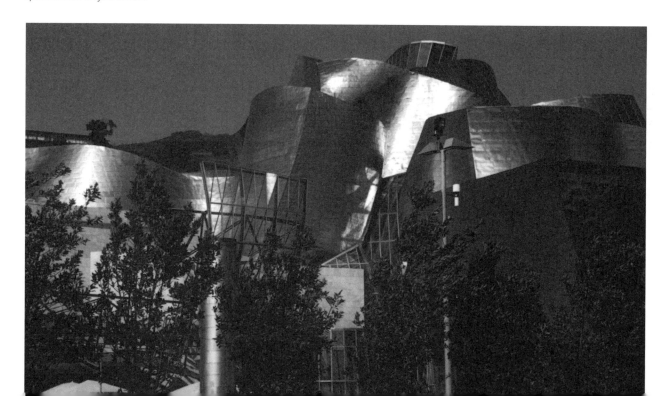

The activity of displaying a group of acquisitions can add layers of meaning to its parts and to the collection as a whole. For example, it may increase our appreciation for the objects or even a collector's overall enjoyment in the process of collecting. Such activity also may allow both viewers and collectors a chance to develop and clarify their understanding of individual objects. This may then spur a collector to modify, add to, or otherwise fine-tune or "improve upon" the collection. As you may have experienced, collecting often encourages an avid and meticulous dedication—whether the subject is antiquarian books or baseball cards. Over time, such dedicated efforts have been the basis for many of the world's greatest collections of art.

This first chapter explores what the art museum has to offer to the general public. It then provides an overview of the functions and history of the museum. Next, an argument is presented for making the museum an integral part of the art curriculum. Lastly, the chapter offers a glimpse of topics to be covered in the rest of the book.

Why Use the Museum?

Art museums play an important role in many human societies. By their very nature, museums reflect the basic human impulse to collect. They are also reflections of the attending characteristics of organization, maintenance, and display. Museums offer evidence of our human cultural heritage, they inform us of our creative nature, and they provide excellent and often inspirational examples of the visual arts. In the best-case scenario, collections of art also prompt viewers to think about art objects in new and different ways. Another way to think of museums is that they offer opportunities to learn, and in addition they inspire us, enlarge our vision, and sometimes change our perspectives.

By collecting objects from various historical periods, art museums document multiple aspects of humankind and artistic expression, including art as a reflection of emotions, intelligence, and the human condition in general. For instance, an ancient vase may reveal the Greek ideals of beauty and balance. A painting by Mary Cassatt may embody the emotional attachment between a mother and her child. A single art object also may give evidence of an individual artist's ideas, hopes, triumphs, or misfortunes.

Most museums strive to acquire exemplary pieces, and thus their collections can also inform us of the history of artistic achievement over time. Since artistic expressions travel across art forms and subject matter, they can provide viewers with a perspective of conventions, traditions, influences, and aesthetic vocabularies. Artists naturally respond to the context of the time in which they live. So, for example, the subjects chosen by medieval artists and the ways in which they depicted those subjects can tell us much about the spirit of the time, the role of art, the evolving pictorial craft, and even the influence of the Church.

Another significant contribution of the museum is its role as a storehouse of stories—stories from many cultures and from times both past and present. Burial goods, for example, can bring to life the actions and thoughts of people who lived in Egypt thousands of years ago. And everyday objects, such as implements for eating or grooming, educate us about the diversity of approaches to domestic activities. When exposed to these stories, we can in turn reflect on our own times, culture, and values.

Museums make an important contribution to society. People who spend their time working at art museums—museum professionals—devote their lives to asking questions about art. As a result, they offer interesting ideas for museum visitors to consider.

Some Definitions

Art Museum—An institution that acquires, protects, researches, and displays art.

Permanent Collection—The works owned by an art museum.

Exhibition—A selection of displayed art objects based on a theme. An exhibition will often include works displayed on gallery walls as well as works displayed in cases.

Student Talk: What Is an Art Museum?

"An art museum has lots of sculptures and painting from many famous artists. It is usually a big place. Paintings are there of the artist themselves and other things like *The Scream*. Some things are very old. Tour guides show people art. There are fiber works, and there is pottery at an art museum. The museum is divided into sections. Some people go there to study about art. They come from different countries. That is what an art museum is."

—Lauren, age 9

"An art museum is a place to see all kinds of art, from modern paintings to 300-year-old sculptures. In an art museum, the arts are divided in sections. For instance, the Egyptians are in the Egyptian section and so on. In front of most of the art there is information on that piece of art, like when it was made, where it was made, and who made it. The people that are in an art museum are usually tourists looking at the beautiful art from miles around. An art museum is also a place to learn about art and artists."[2]

—Josephine, age 10

An Overview of the Museum

Art museums are enchanting and entertaining places, and offer opportunities for discovery. But museums are also multifaceted professional institutions with individual histories and missions that influence how they operate. A museum's primary mission is to preserve, safeguard, and exhibit significant artifacts of aesthetic value. By acquiring and caring for works of art, museums provide a service to society by advancing knowledge and understanding of culture.

Art museums are by their very nature complex institutions, balancing specialized departments, a variety of services, and diverse staffs devoted to making everything run smoothly. Museums around the world vary greatly by type and scope, and their size and scope often determine organizational and staffing patterns.

The museum director is usually the highest administrator, and he/she answers to a governing board. Curators are typically associated with the care of collections, and their duties may involve research, organizing exhibitions, and preservation, among others. The title Curator can also be used to describe museum educators. Additional staff members may have backgrounds in art history, museum studies, art education, or design; many have terminal degrees in their disciplines. Support personnel include clerical, janitorial, and other individuals. Volunteers are also critical museum workers; they may serve as guides or salespeople, and in various other capacities.

As individual institutions, museums must meet the highest standards of the profession. The American Association of Museums sets the criteria of excellence in practice across all types of museums. As part of its accreditation program, it defines the museum as a permanent, nonprofit institution that exhibits artifacts of aesthetic interest on a regular basis. This accreditation program, which entails a rigorous and

intensive review process, ensures museum account-ability to the general public. Acceptance represents recognition of responsible and exemplary service to the public.

A Brief History

The complexity of the art museum belies its short history in the United States. It was not until the late eighteenth century that art museums began to appear on these shores, although collections existed from the time of the ancient Greeks and Romans.[3] As the concerns of a young, developing nation enlarged to encompass less urgent matters, institutions in which artworks were collected and exhibited began to grow. Art museums were slow to develop, however, and the early models were simpler and arranged differently from those with which we are familiar today.

The modern conception of the museum can be traced to the humanistic interests of the European Renaissance, when collectors and patrons amassed large numbers of art objects including antiquities, jewels, paintings, and other "curiosities." Collectors were often members of the nobility or clergy; rich individuals, including bankers and other successful business people; as well as members of royalty. Many became connoisseurs who sought only pieces of the highest quality.

From the fifteenth through the eighteenth centuries, private collections continued to grow in the Western world as the wealthy and powerful gathered hordes of treasures. Political conquests, social turmoil, changes in rulers, and other factors shuffled the ownership of many European collections. By the seventeenth century, private collections were slowly beginning to become accessible to wider audiences. And special settings and buildings were sometimes erected to make public displays and exhibits of pri-vate collections possible. When the Louvre opened its doors to the public in 1793 during the French Revolution, it dramatically altered the definition of "museum." For the first time, art was being made available to all who wished to see it. Further political upheavals in Europe coupled with changes brought about by the Industrial Revolution led to a dramatic rise in the number of public museums in almost all countries of the Western world.

During the 1780s, in the young United States, Charles Willson Peale set up a museum in his Philadelphia home. There he displayed various natur-al history artifacts alongside paintings, which were considered important from a primarily historical point of view at the time. Likewise, the Boston Athenaeum, principally a library, also housed sculp-ture and paintings. These would later become part of the holdings of the Boston Museum of Fine Arts.

The last quarter of the nineteenth century launched an important period of museum growth in

1.2 After a tour of the John and Mable Ringling Museum of Art in Sarasota, Florida, students chose outdoor sculpture to draw. Teacher: John Delp.

this country. Industrialization during the post-Civil War period led to the rise of the wealthy class, including industrialists. This class sought culture. And for some, collecting and making art available to the general public became a passion. It was during this time that the philosophical basis of the modern art museum began to emerge. Two U.S. institutions, both established in 1870, defined the meaning of the new comprehensive museum: The Metropolitan Museum of Art in New York and the Museum of Fine Arts in Boston. These institutions developed strong, extensive, and distinctive collections. The financial support of wealthy patrons—along with continual bequests from private collectors—led to an accumulation of artifacts of the highest quality. These collections, like others that formed within the decade, encompassed what was considered to be "great art," which meant examples of classical art, fine paintings and sculptures, high quality decorative arts, and additional select artifacts deemed masterpieces of their kind. Thus was established a pattern for defining what was art . . . and what was not.

During the next decade, succeeding encyclopedic collections followed, including the Philadelphia Museum of Art, the Corcoran Gallery of Art in Washington, D.C., and the Art Institute of Chicago. Subsequent smaller art collections using the same model appeared at the turn of the century. They too resulted from the interests of private affluent art collectors, but were often less comprehensive in scope. Examples include the Isabella Stewart Gardner Museum in Boston, the Frick Collection in New York City, and the Phillips Collection in Washington, D.C. These collections and others contributed to the move toward opening art museums throughout the country.

Within a century after the first comprehensive collections had begun to emerge, the United States had produced institutions, and amassed collections, of world renown. And by the 1970s, three museums of modern art—the Museum of Modern Art, the Solomon R. Guggenheim Museum, and the Whitney Museum of American Art—were indicators that the center of the artworld, which had begun to shift away from Paris decades earlier, was now most definitely in New York.

Today, art museums are yet again moving in new directions—often redefining the traditional definitions of what art and museums are thought to be. For instance, institutions are now exhibiting works that would not have been shown early in the history of art museums, or even a generation ago, including folk art, computer art, motorcycles, and guitars. Moreover, concerns about meeting the needs of various cultures have become increasingly important both in terms of what is exhibited and how the general public is served. And this has caused many museums to rethink the role they play in a community.

Museum Functions

The work of most art museums centers around four important functions—acquiring, preserving, and exhibiting works and also educating the general public about them. Museum collections originate for different reasons, and collecting patterns vary across institutions—reflecting the motivation and tastes of curators, private collectors, and benefactors. Museum collections are not static. They must grow and change to make continual contributions to knowledge about art, to maintain standards of excellence in art, and to reflect a balanced view of creative expressions. This constant evolution requires a systematic approach to acquiring objects and refining collections, and it sometimes prompts the removal of certain artifacts.

As we have seen, closely tied to collecting is the process of caring for a collection. This represents the less visible work of museum staff, yet it is critical to the life of the institution. Museum staff study objects in an effort to document and catalog their history. They also protect artworks by controlling environmental conditions, such as humidity, temperature, and levels of light. Museum guards, display cases, and electronic alarm systems contribute to the safeguarding of objects. Related to these preservation efforts is the cleaning and repair of individual works; select members of a museum staff are specifically trained in the restoration and conservation of objects, and their work can in turn help advance the knowledge about artifacts in general. Sophisticated technology—such as X-rays, infrared light, and microscopes—are also important aspects of this often complex process.

As mentioned above, the display or exhibiting of artifacts is also crucial to collections. Experts devote special attention to methods of organization, presentation, labeling, and lighting so that visitors can best enjoy, appreciate, and understand what they are viewing. Museums often rely on chronological sequencing when displaying artifacts to reflect the history of objects on view. Another increasingly important aspect of museum display is determining how to facilitate the public's interaction with art. Today's museum professionals often study how visitors respond to exhibits in an effort to improve future displays.

Unlike most personal collections on display in a home or office, museum collections also represent another vital and important factor: education. The knowledge and insights of museum professionals assist them in interpreting the meaning and uncovering the history of objects in their collections. An educational responsibility to the general public is

Discussion Point

Supermarkets, clothing stores, and other commercial vendors devote time to creating visually interesting and appealing displays. What are the differences between commercial displays and those found in art museums? Ask students to explain why there are differences. Additional questions to pose are: How do art museums make exhibits interesting to see? Do science and art museums differ in the manner in which they display objects? Why are there differences? What can we learn from commercial displays about attracting potential buyers? Can we apply that to a bulletin board? What other environments have visual displays?

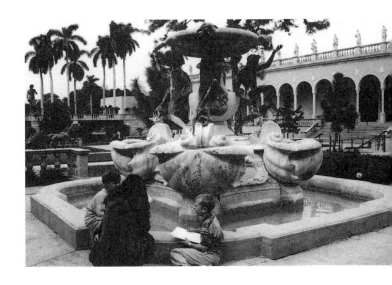

1.3 Fifth-grade students visiting the John and Mable Ringling Museum of Art create drawings on the grounds of the museum. Teacher: John Delp.

Try This

Have students bring their collections of objects whether they are baseball cards, dolls, or other types of objects. Ask them to list the criteria they used when making decisions in acquiring them. If items were gifts, ask them to identify what might have been the occasions and factors behind them. Encourage students to compare notes. Lead students in linking their discussed ideas to the collecting practices of the museum.

Try This

Ask students to bring in a blend of objects—things they love, hate, use every day, or items that were gifts. Have students order them in some kind of logical manner. They could organize by type, by visual features, or by function. Students should work in small groups and complete a worksheet that asks them for ordering strategies.

Once this exercise is complete, review with students the various approaches used to organize objects. Next, lead a discussion about how students' ideas compare to the museum's approach of arranging art in a gallery. You might also help students distinguish between collecting and exhibiting art and non-art objects such as rocks, arrowheads, and political memorabilia. Questions to pursue: *What might be considerations for the care of these pieces? How would collectors differ? What might they do with their collections?*

apparent in research projects, tours and lectures, outreach services, and various published materials such as guides and catalogs. These various formats not only describe and identify objects, but also provide a context for helping visitors understand the art on view and, indeed, art in general.

The Curricular Importance of the Museum

Museum collections offer the chance to contemplate cultural achievements at the same time that they represent catalysts for educational instruction. If viewing works of art can lead to an understanding of the relationship between humans and material objects and, ultimately, an appreciation for the human creative spirit, then surely it is imperative to develop ways to continually expose our students to such experiences. This can include—but is not limited to—building awareness of the institutions themselves, introduction to a variety of ways to use a museum, and development of knowledge of an institution's specific contents. Whether art teachers wish to plan direct experiences with original works of art for their students or provide in-class instruction, they have at their disposal various instructional resources. And in either case, these goals are relevant to both educational practices, in general, and to the art curriculum, in particular.

In their daily lives, children and young adults interact with all kinds of items, which may fascinate or interest them for a variety of reasons. Like adults, students may collect objects including baseball cards, seashells, models, computer games, or any number of other articles. Even many of the youngest students will have experience as "collectors" of stuffed animals, videocassettes, or picture books. Some may organize a collection by categories and take great care to safeguard and display it. And many may enjoy discussing their collections at great length.

There are natural parallels between art museums and students' personal collections. And although not all students acquire objects and respond to the material world in the same manner, art educators can at the very least take advantage of children's natural inquisitiveness about things and their abilities as visual learners. Even the simplest and most direct ways in which students interact with objects are a meaningful reflection of the role that art museums play in our society: just as students have opinions and make decisions about objects, so do museums. This can be an excellent starting point or link for helping students to conceptualize the idea of a museum as an institution and to understand the museum and its collection as part of the art education curriculum.

Teaching Strategies
The following paragraphs introduce examples of some of the specific teaching strategies that will be found throughout this book.

The Functions and Practices of Art Museums
The existing art education curriculum is a natural starting point for instruction pertaining to museums. An art teacher can slightly modify current lessons by inserting brief discussions about the museum and its functions. For example, during a studio activity, students might speculate about the display and care of their own art and make comparisons to objects found in a museum or gallery. Students could also look at the conditions that can harm art, such as moisture or sunlight. Special activities revolving around museum functions need not require elaborate effort. Sorting activities, for instance, using found objects or postcards, can assist students in examining the ordering of art in a gallery setting. CD-ROMs of museum collections and Internet resources such as museum Web sites can also amplify students' knowledge and

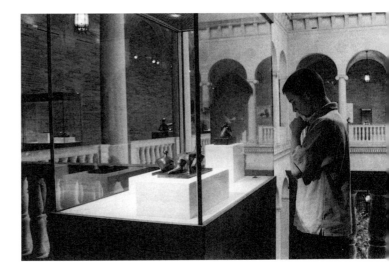

1.4 The depth of this student's museum experience depends, in part, upon knowledge of art introduced in the classroom. Nelson-Atkins Museum of Art, Kansas City, Missouri. Teacher: Elizabeth Hatchett.

understanding. Equipped with a few instructional resources, the art classroom can become an arena for countless interesting and relevant examinations of the art museum and its practices.

Incorporating Art from Museum Collections
Whenever possible, the works of art themselves can inspire discussions of the processes and techniques artists use to create them. Specific gallery displays can highlight the unique solutions that artists applied to visual problems inherent in each period in the history of art. For example, modern pigments, when compared to egg tempera, have expanded painters' abilities to express themselves. Exposure to original works of art also allows students to observe in detail how artists executed their works and to make more fruitful comparisons among them, since many aspects are not observable in reproduction form. Furthermore, such viewing experiences can

Museums Display Collections

Students may or may not display their possessions, but they can begin to think about ways to best present objects to encourage appreciation. Students could sketch out ideas for displaying T-shirts, in-line skates, dolls, and other types of items. Art teachers could provide effective display techniques so students can create their own that feature the function, aesthetic properties, and design of articles. Teachers typically have art shows and these events offer yet another way to think about museum exhibitions.

Classroom Connections

The care and repair of objects may not be an important part of students' collections. In fact, our society does not emphasize preserving material goods in general. In contrast, museums take painstaking efforts to preserve and conserve artifacts. The topic of preservation could provide an opportunity to discuss what to do when things break, no longer function, or lose value. Studio projects could also be examined in terms of how to best protect them. You might also show students how to repair studio projects that have been damaged.

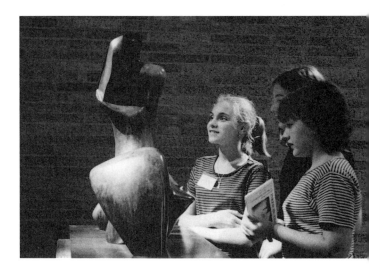

1.5 Elementary students visiting the Nelson-Atkins Museum of Art, Kansas City, Missouri. Teacher: Elizabeth Hatchett.

ignite a learner's imagination and motivation, prompting new solutions to challenges encountered in the classroom and studio.

Collecting and Exhibiting Art

Museums also convey implicit messages about the value of art. Although these institutions have expended great efforts to acquire all types of art objects, some have not always been equitable in their attention to diverse peoples. Art museums, throughout their histories, have held aesthetic values concerning what was precious and valuable, which sent strong messages to the public. For example, art created by women has been ignored for a good portion of the history of art. These issues can reveal much about a museum, including its limitations, and can become fuel for any number of discussions, debates, and research projects to help students develop a deeper, more meaningful, and more relevant understanding of art.

Museums and Society

The art museum can also be a starting place for students to become aware of the cultural institutions within their community as well as the important role that such organizations often play in a state or country. In addition to museums, artworks are often displayed in public libraries, municipal offices, public parks, senior centers, hospitals, churches, and workplaces. Other professional art settings include auction houses, commercial galleries, and art openings. A teacher can use such venues to inform students about the artistic interests and endeavors of local citizens and artists, among many other topics. The exploration of such places can also prompt discussions about the political, economic, and market issues that are also part of the art world as well as the different roles played by these various institutions. Such places can also provide examples of original works of art when an actual art museum is not easily accessed.

A related topic is the social responsibilities of the museum and whether an institution is making headway in meeting them. In recent years, art museums have become increasingly responsive to communities. Diversity issues and funding concerns have steered institutions in the direction of devoting greater attention to audiences and their educational needs. Outreach programs, collaborations with community organizations, and family events help draw in new visitors. A museum's permanent and special exhibits, recent acquisitions, and events reveal how an institution strives to reach out to the community, and students can benefit by taking any or all of these issues into consideration.

Discussion Point

Cities have old and new buildings. They may have things we see in an art museum such as sculptures, fountains, and architectural details. These features of a city or town can be viewed as beautiful and worthy of our notice. Have students pay attention to such features in their own city or town. They should make lists and, when possible, include photographs of what they believe is beautiful and worthy of attention.

Try This

When creating portraits, artists often include items of importance to the sitter. These objects sometimes represent the occupation, avocation, or career of individuals. Ask students to create a self-portrait that shows their collections of items. If students do not have a collection, they can choose things that are meaningful to them in some way. Objects could represent a memory, a person, or an enjoyable activity.

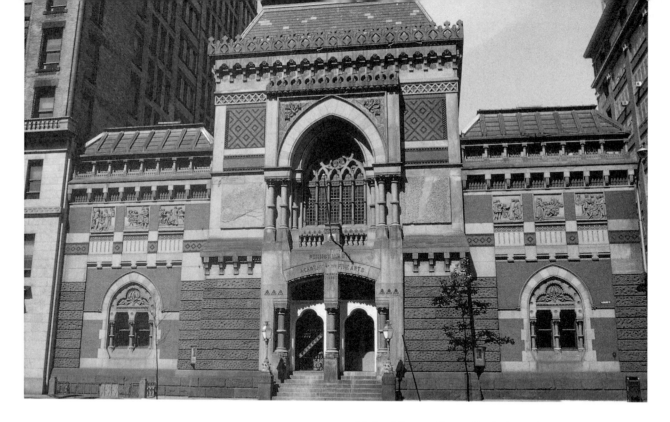

1.6 *Frank Furness, George Hewitt,* Pennsylvania Academy of Fine Arts, *1871–76. Philadelphia. Photo: Davis Art Slides.*

Upcoming Chapters

The art educator's challenge is to determine how to best use the museum as a resource. This book is intended to provide the art educator with ideas for making the art museum a viable component of the art curriculum at the elementary and high school levels. Teaching examples are provided throughout, illustrating ways to make the museum part of a comprehensive art program. Educators who rely on the museum and its resources come to realize that numerous instructional possibilities exist. They also realize that students' understanding about art gains depth when instruction entails thinking about the museum and its cultural contributions to society.

The following chapter examines the process of planning a field trip to a museum. Chapter 3 considers how educators can regularly address issues related to the museum and ways to integrate such issues in meaningful ways. Chapter 4 offers suggestions for developing rewarding relationships between schools and museums, and Chapter 5 explores the Internet as an educational resource. The additional resource of local history museums is covered in Chapter 6. The final chapter suggests ways that educators can help students and their families become involved with art on their own time.

Conclusion

The process of including the museum can be thought of as a journey, from gaining inspiration for classroom discussions to the development of lessons and units for studio, criticism, aesthetics, and art history investigations. Existing curriculum can be the starting point from which natural connections with collections can be identified. Conversely, one can look to museums to determine how their works fit into the art curriculum. Probably the best way to begin including the museum as part of your educational plan is to start with small steps. You might begin by following just one or two of the many suggestions included in this book. As you increase your curricular involvement with museums, you may well find that they become an integral part of your own and your students' daily engagement with art.

Notes

1 Interview with Carole Debuse, fall, 1997.

2 Student responses, Valley Park Elementary, Overland Park, Kansas; Joyce Huser, teacher.

3 E. P. Alexander, *Museums in Motion*. Nashville, Tennessee: American Association for State and Local History, 1979.

Chapter

2

Museum Field Trips

"[The museum] is just our classroom away from the classroom."
 —Loretta S. Hopper, second-grade teacher

Art teachers must make a multitude of decisions about how to achieve their goals for covering the art curriculum. The options available to them are often numerous, which can make the choices exciting. One option is to have students participate in a field trip to a museum. Viewing museum collections can broaden and enrich classroom instruction and also give students the opportunity to view actual works of art.

This chapter considers the art museum as a pedagogical site. In essence, it examines the process of planning a museum field trip, suggests methods to prepare teachers and students for such an experience, and offers ideas to promote student learning before, during, and after a museum visit.

Museum and School Environments

The art museum and the school are fundamentally
different institutions. The mission of a museum is to
acquire, preserve, protect, and interpret works. By
contrast, the mission of a school is to educate its stu-
dents in an effort to prepare them for the future.
For a school to be successful, it must provide students
with the knowledge and skills necessary to function
as citizens and members of society.

To achieve their respective missions, art museums
and schools offer distinct learning experiences.
Museums afford numerous visitors the chance to
simultaneously view original works of art. These visi-
tors usually have the freedom to select individual and
idiosyncratic pathways and approaches to the works
of their choice. The way visitors use both time and
space during a museum experience is unstructured,
and the learning that occurs is informal. Labels and
brochures may assist in this learning process, but the
viewer is essentially on her or his own.

Schools, on the other hand, are highly structured
environments. They have predetermined, exacting
schedules (both short term and long term) that gov-
ern all activities and control both the use of time and
specific spaces. What students should know and be
able to do is outlined in the form of national, state,
or local standards. Curriculum is designed to help
students to meet these learning outcomes and to
assess the extent to which they are successful in
meeting them.

Related to these inherent differences between
museum and school environments are the individual
concerns of museum educators and classroom teach-
ers. Museum educators direct much of their attention
to objects as well as the history, interpretation, and
protection of objects. They may not be attuned to
the responsibilities that teachers face in the class-
room. Teachers tend to think in terms of school cul-

ture—pedagogy, the curriculum, time, schedules, and order. Because of these differences, as well as their diverse educational backgrounds, members of both groups need to consciously align their perceptions and expectations for a museum visit.

The Museum Experience

A meaningful museum experience is one in which students expand their aesthetic sensibilities and their understanding of art as a human endeavor. Successful museum field trips will increase the significance of encounters that students have with works of art back in the classroom, and in other subject areas. Visits can also increase students' comfort levels in museum settings. When students come to consider a museum as an exciting place and an environment in which to learn, they will be more likely to frequent such institutions later in life. Additionally, they may grow to appreciate local cultural institutions as valuable aspects of their community.

To help students gain the most from a museum visit, carefully consider a broad set of issues related to the experience. By taking a class to an art museum, you may be exposing students to such a setting for the first time. The experience thus incorporates a host of variables that can influence behavior and learning potential as well as the memories that students will take away with them.

Three intersecting variables of such a visit are the personal, social, and physical contexts. Individually and as a whole, these categories contribute to each student's museum experience.[2] Considering them when planning a visit can lead to greater success for everyone involved.

The Personal Context

For students, the personal context is all that they bring with them to the museum. This includes any memories of prior museum visits (whether with family, friends, or classroom teachers), which naturally influence their expectations. If a student has been to an art museum, there is a good chance that his or her ideas and expectations for a prospective visit will align with a teacher's agenda. Students who have not experienced an art museum may be able to draw upon similar or related experiences, such as visiting a science museum, historic home, or even a national park or zoo. They also may have acquired relevant background information from family members or peers. Some students, however, may have no personal context or useful guidelines to help them form valid expectations for the experience, including appropriate behavior.

The personal context also includes a student's knowledge and understanding of art; this is critical to a museum experience. If students have sufficient preparatory information about the collections they will see, they will be more likely to benefit from the visit. If students have little prior knowledge to draw upon, they may not enjoy the experience or learn as much from the visit as they otherwise would have.

Important questions to consider about the personal context before planning a museum field trip include:

- Have students been to museums?
- If so, to what types of institutions?
- What do they know about them?
- What background information might students need to know about the museum and works of art they will be seeing?

Interdisciplinary Museum Connections

Loretta S. Hopper, a second grade classroom teacher in Chapel Hill, North Carolina, uses the Ackland Art Museum throughout the school year. She integrates museum works and concepts into various classroom subjects—including math, science, and language arts—as well as art. Her students visit the Ackland on a monthly basis, and each visit is linked to the curriculum. Students complete projects, such as written assignments (plays, stories, etc.) and science and studio projects, that are kept in portfolios. At the end of the school year, students present the portfolios to their parents at the Ackland during an evening museum visit.

One visit exposed second graders to parts of the institution not ordinarily seen by the public—the design shop and storage area. In the conservation and restoration area, students learned how a museum professional organizes, stores, and repairs works on paper. To help students study the effects of weather on art, Hopper followed the visit by introducing two classroom science projects.

The first experiment consists of discovering how paper changes when exposed to different light conditions for different periods of time, such as one, two, and three weeks. A piece of paper, acting as the constant, is attached to a learning log, placed in a manila envelope, and stored in a closet. Other sheets of the same paper are kept in various places. The second experiment requires that students divide a rectangular piece of wood into four squares. A different media is applied to each square—watercolor marker, watercolor paint, acrylic paint, and oil pastel. Students predict how the wood might be affected by various weather conditions. Students then observe changes; compare them to a stored, unexposed constant; and record their findings. At the end of both experiments, students formulate conclusions based on noted observations.

The Social Context

Student peers, teachers, chaperones, and museum staff represent the social context of a museum visit; they all come to bear upon each student's experience. If museum educators play an active role in your class's visit, they have great potential for affecting student learning. But even outside individuals—such as guards and other museum visitors or classes—may have an impact. These social dimensions can enhance the visit or become causes for distraction.

When planning a field trip, ask the following questions about the social context:

- What are the social dynamics of my class?
- What kinds of visitors are students likely to encounter?
- Who can serve as chaperones?
- Which students may require special consideration?

The Physical Context

The layout of the museum represents the general physical context. This includes the exhibit spaces and individual works of art as well as the gift shop, restrooms, elevators, stairways, and cafeteria. In combination, these parts can obviously have a great positive or negative influence on a museum visit. Even simple aspects of the physical context—such as a museum's size and floor plan—can affect the ability to learn. The novelty of a specific setting is also a critical issue for students; first-time visitors will naturally respond differently to the environment than those with prior knowledge.

Consider practical questions about the physical context, such as:

- How will the museum's size and the nature of the exhibit affect students?
- Where can students have lunch or a snack?
- Will it be necessary or desirable to divide the class into small groups?

Museum Offerings

Perhaps one of the most important tasks to accomplish before planning a museum field trip is to contact the museum's education department. You will learn about dates and times of student tours, special exhibits, and other educational services. You will also gain practical information about fees, hours of operation, requirements for reservations, and the number of chaperones recommended for your group.

Contacting an education staff member also allows examination of various pedagogical issues in relation to the museum experience you foresee for students. This may include information about the kind of instruction that is usually offered to student visitors within the galleries, who the gallery instructors will be, and the typical length of tours. Furthermore, contacting a member of the museum education staff can provide a chance to share and develop your own ideas, needs, and goals. Such open communication can often lay the groundwork for a solid working relationship with the museum education department. Ideally, you may become ongoing partners who work together to provide students with profound educational experiences.

Educational Choices

Museum educators often design educational services to meet specific school needs. This approach can help you align a field trip with your current art curriculum. In an effort to meet such needs, museum education departments routinely offer a menu of options. Remember, not all museum services are alike—it is imperative to discover exactly what services an institution offers before you begin formulating a plan.

A museum's collection represents the heart of the institution; it is what makes each museum unique. And this uniqueness can offer students a distinct type of art experience. Some collections, for example, may

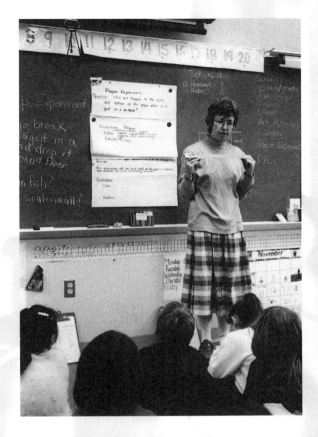

2.1 Loretta S. Hopper encourages second graders to speculate about how light may affect art materials.

Teaching Tip

Some museums allow students to draw in the galleries. It is important to inquire as to the policy before deciding to implement this activity in the museum. You may wish to incorporate student sketches into a lesson. Students could sketch artworks in an effort to become sensitive to the artist's approach to subject matter, composition, symbolism, and so on.

Carolyn Ann Daniels, an elementary art teacher at the Applied Learning Center in Fort Worth, Texas, prepares students for a visit at the Amon Carter Museum by using museum packets. She shows students slides and discusses each image. Students and teacher talk about the artists and the art. Daniels says that she makes it possible for students to like or dislike artwork with the proviso that they support their opinions with ideas and observations.[3]

2.2 Students from Ephesus Elementary School visiting the Ackland Art Museum, Chapel Hill, North Carolina on a "Taking Care of Art" tour. Teacher: Loretta Hopper.

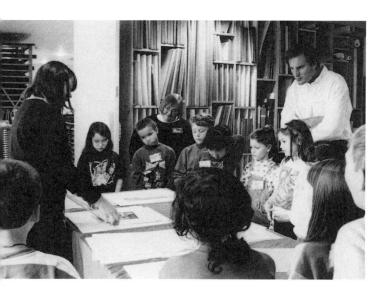

emphasize the work of local artists, whereas others might collect works that are representative of a specific historical era. Many large museums display works from a variety of cultures and periods. More specialized institutions may concentrate exclusively on works by Asian, African, or women artists—to name just a few options. Consider a museum's focus in order to take full advantage of what the institution offers.

Most museum educators will work with teachers, tailoring their services to meet specific classroom needs (such as addressing students' ability levels or supporting a current theme). Ultimately, the teacher knows her or his own teaching situation best, and must carefully look at how museum services fit with her or his instructional goals and resources.

Docents

Docents represent another potentially significant part of your students' museum experience. When you request educational services from a museum, ask about the role these individuals will play during your visit. In general, docents interpret collections through tours and instruction and provide the majority of museum instruction for the general public, including school populations. Their contributions make it possible for museums to implement educational goals for visiting elementary and secondary students.

Docents usually enter museum volunteer teaching because they are interested in art or history, and they receive specialized instruction to prepare them for this work. Museum educators and curators typically provide much of docent education. This education varies from one museum to another, but generally consists of studying art history and museum collections for six months to more than a year.

Docents learn various ways of teaching a wide spectrum of visitors. They are usually well versed in touring techniques, such as guided discussion, lec-

ture, and dialogue. Docents may engage students in activities as diverse as storytelling, writing, role-playing, and gallery games. They also may rely on viewing strategies that emphasize the symbolic and formal elements of works of art. Yet, keep in mind that you are most familiar with your students and how they learn. Docents are likely to need your assistance in providing effective museum instruction.

Planning the Visit

Following is a list of some educational services that are common to most museums. These descriptions are generic; specific tours and services will differ in content and scope for both elementary and secondary levels. In addition to these services, a number of institutions offer support by providing pre- and post-visit instruction. This may consist of discussions about works, art-making activities, or other hands-on projects.

A useful, comprehensive checklist for planning a museum visit is provided in the Appendix, on page 112. You may adapt the list, or use just as it is.

Museum Tours

Tours might concentrate on a specific theme reflected by a collection, or they may be used as a tool to help develop students' observational skills. Whether guided by a museum staff member, part of a multiple-visit program or workshop, or self-guided, a museum tour is an excellent opportunity to introduce students to new ways of looking at and analyzing works of art.

Guided Tours

These can cover permanent collections or special exhibits. Guided tours may make use of lectures, discussions, gallery games, writing activities, and other teaching methods. An introductory guided tour usu-ally functions as an overview of a museum—for example, a tour of a collection's masterpieces or highlights. It also may function as a "learning to look" tour. Special topic guided tours might focus on a particular area or aspect of a permanent collection to suit your art curriculum, such as Impressionist paintings, ceramics, or African masks.

Multiple-Visit Programs

Some museums may offer multiple-visit tours in which students will visit a collection two or more times. This type of experience can provide more in-depth information and greater learning opportunities. You might also combine multiple-visit programs with follow-up classroom activities. Such experiences can enhance the museum visits and assist students in understanding what they have seen in a collection.

Workshop Tours

Museums also may offer workshop tours that link guided tours to art-making activities. A workshop tour will include a hands-on component; this might be an opportunity for students to sketch in one of the galleries, work in a museum studio to create art inspired by a tour, or participate in a writing activity, such as creating poems inspired by the visit or a specific work of art. You may have the opportunity to choose art-making processes and materials that relate to current curriculum topics.

Self-Guided Tours

Some teachers may wish to lead their own students through a collection. In these instances, you have the flexibility to choose your own topic or area of focus. You might still obtain assistance from museum educators as you design various components of the visit. Museums generally have specific policies regarding self-guided tours; it is important to research these

A Closer Look at Teaching Practice

Deborah A. Herbert, an elementary art teacher at Garden Elementary in Venice, Florida, provided pre-museum instruction for students who would see the "Dreamer Builder" exhibit at the John and Mable Ringling Museum of Art in Sarasota. She engaged students in studio activities, preparatory experiences, and aesthetics and criticism exercises. She brought in an architect to discuss his career as well as conduct a charette with students. In essence, she implements "multi-experiential activities to get [students] ready."[4]

policies before proceeding. Some institutions will allow self-guided tours only during certain times. They also may limit the number of students allowed in a gallery. Museums also may request that you be accompanied by a specific number of chaperones. (See page 23 for more information about chaperones.)

Museum Lessons

Museum lessons are valuable educational experiences that reflect specific classroom topics. They are typically planned by museum educators in conjunction with teachers. Such lessons can be developed to offer a close fit with your art curriculum and specific needs. Museum lessons require effort on the part of the teacher, who is responsible for providing information about the art curriculum and assisting museum educators in planning the lesson.

Teacher Resource Packets

Museum educators routinely develop educational materials linked to their tours and programs. They often offer resource packets that contain numerous teaching aids useful for both classroom and gallery-based instruction. These packets might suggest a number of entry points for introducing students to a collection or a specific work of art.

A teacher resource packet typically may include slides or prints, historical information, and contextual information about key artists and works. Packets also may contain lesson plans, ideas for curricular connections, and student worksheets. You may adapt any or all of the content to fit your curriculum needs.

Other Educational Services

Many museum education departments offer additional services and products—from simple museum brochures to complex, in-class presentations.

Departments may lend slide sets, videotapes, or support kits related to their permanent collection or a special exhibit. Such kits may contain hands-on materials, teacher guides, and information relevant to art curricula. Presentations vary at different institutions, but for the most part such offerings can help you to supplement your classroom instruction.

Chaperones

Chaperones help teachers make the most of the time spent at a museum. As mentioned earlier, it is important to have the required or recommended number of chaperones for your visit. You also should provide all chaperones (and any alternates) with the schedule or plan for the field trip. Clearly outline any responsibilities they will have during the visit. If possible, also describe the galleries and any activities that will occur there. If chaperones are informed of the specifics in advance, they will be more likely to enjoy the experience and better able to carry out their duties.

You also might provide chaperones with hints for assisting students and for maintaining appropriate museum behavior. It may be beneficial to assign chaperones to oversee specific groups of students; this will help them to steer students to your intended destination upon arrival and guide students throughout the visit. If possible, rely on chaperones who are familiar with the museum; they will be better able to focus their attention and keep students in line with expected behavior. If this is to be a chaperone's first visit, you might assign him or her a group of students who do not pose much of a challenge.

Preparing for Learning

Finding ways to capitalize on educational opportunities is one of the challenges of teaching. Proper preparation can be of immense benefit. Whether your students will participate in a tour guided by museum staff or by you, preparing yourself and them will enable students to learn all they can from the educational opportunities that occur.

Reviewing background information about the original works of art that make up a museum's collection is one important method of preparation. Each work will have unique qualities, and both teacher and students should learn to become keenly sensitive to them. For example, the close observation of an original object—whether a painting, sculpture, tapestry, or print—can provide pertinent information about its size, color, textural quality, and other characteristics. In turn, each of these may contribute to the overall impact of the work. They also may play a key role in interpreting a work's meaning and in understanding an artist's intentions or the original purpose (or use) of the artwork.

2.3 Second graders from Ephesus Elementary School in Chapel Hill, North Carolina learn about some ways that prints and other works on paper can be damaged and restored.

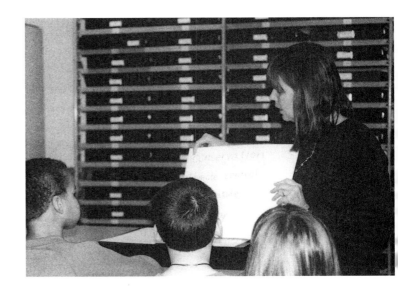

Pre-Visit Activity

Studio

Students choose to study a reproduction of one art-
work that they will see at the museum. They look
at the medium, style, and related characteristics and
create a piece inspired by that work in the same
medium. Students could compare their work with
the original when they visit the museum.

*2.4 Scott Frost, Untitled, 1998. Print, 3 3/4 x 5 1/2"
(9.5 x 14 cm).*
*Prior to seeing "Inked in Time" at the Nelson-Atkins
Museum of Art, Elizabeth Hatchett's students viewed
slides of different types of prints, discussed terms such
as relief, intaglio, serigraph, and lithograph, and
created a print of a subject of their choice.*

*2.5 Katie Young, Untitled, 1988. Print, 5 x 5 1/2" (13 x
14 cm).*
*In preparation for seeing the exhibit "Inked in Time,"
students created a monoprint by drawing a sketch on
paper and transferring it to a cut styrofoam tray.*

Preparing Yourself

The decision to travel to an art museum is neither
simple to make nor easy to implement. Indeed, as a
teacher, you will have myriad tasks to complete
before the bus or van leaves the school's parking lot.
One of these tasks is to address the issue of teaching
schedules. As a special subject teacher, art teachers
service a number of classes each day. Canceling any
of these can become a sensitive issue for colleagues.
Organizing a field trip requires careful thinking
about schedules and whether or not it is necessary to
negotiate changes to class times.

Another issue is the availability of funding for
transportation and entrance fees. Fortunately, some
schools build funding for field trips into their operat-
ing budgets. If such funds are unavailable, parent
organizations—such as PTAs or PTOs—can be instru-
mental in providing resources and should be involved
in planning trips. Also, your school principal can be
supportive and informative about these and other
related issues.

To plan a meaningful and memorable museum
experience for your students, it is helpful to first pre-
view a museum exhibit or collection on your own. This
will help you to determine what might be most rele-
vant for your goals, to familiarize yourself with how
and what information is relayed as part of the setting,
and to prepare students (and chaperones) accordingly.
For example, you may find that a collection is
arranged thematically or chronologically. Subtleties
such as spatial relationships among works, though
easily missed by young students, may offer learning

opportunities. A preparatory visit will also help you to resolve important practical issues, such as concerns about the general layout and any recent changes in museum displays. Planning can be enhanced by working with a museum's educational staff.

One final consideration is the use of name tags. Educators, guards, docents, and chaperones may need to identify and call upon students. You might even go as far as having your students wear something to visually unify them, such as identically colored T-shirts. This can also help you to keep them together as a distinct group, which may be challenging in crowded galleries or special exhibits. Some institutions have specific guidelines about methods of identification.

Preparing Your Students

Once you have decided upon a museum for your field trip, you can begin to prepare your students. Providing them with an introduction to the museum or collection they will view is crucial. At the very least, students should understand what will occur during the visit, be generally familiar with the kind of art they will encounter, and have knowledge of the concepts and vocabulary terms that they are likely to read or hear as part of a gallery discussion or tour. Make sure students have a good idea about what to anticipate in terms of the physical layout and configuration of the site, the staff, and their own expected behavior.

Such preparation will help to engender a good mindset among students, allowing them to be emotionally and cognitively equipped to enter the environment as learners. Remember: students are approaching the museum as appreciators of art. This means that they should have the intellectual structures to absorb the visual and other information they encounter.

 Pre-Visit Activity

Writing Options

Students might write:

- a description of an art museum they would like to design if they were an architect.

- a letter to an artist whose work they will see at the museum. They can describe what they hope to see and do during the visit.

- a proposal outlining what they would choose to place in a children's art museum and why.

- a poem entitled *If I Were a Work of Art in a Museum.*

- a short story about what it might be like if they were allowed to stay in a museum overnight.

- an essay that tells about a previous visit they made to a museum with a family member, friend, or teacher.

 Pre-Visit Activity

Readings

You may read aloud or have students read from books about museums and art, such as (for young students):[5]

The Gentleman and the Kitchen Maid by Diane Stanley

Ella's Trip to the Museum by Elaine Clayton

Museum Activity

Art Picks

Students (individually or in pairs) choose a work of art they would like to own. They must inspect it very closely to determine its unique characteristics in an effort to justify their choice. Have students write about the reasons for their decision.

Museum Activity

Art Clues

Students select a work to study (individually or in pairs) and carefully observe its characteristics. They then complete a worksheet that can be used as part of instruction during the gallery visit, or later in the classroom.

2.6 Gallery at the Nelson-Atkins Museum of Art, Kansas City, Missouri.

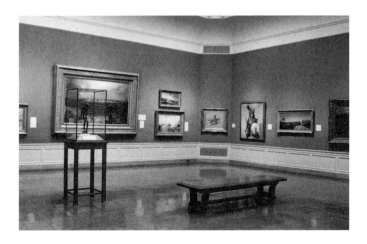

Students also should understand what makes this museum unique or special. Does the collection or exhibit cover a particular period, subject, or type of art? Explain that a collection's contents may be due to the past history of the museum, the community of which it is (or was) a part, the era during which the museum was established, as well as the tastes of the benefactors who contributed works and funding to the institution. You also might mention that many museums change their exhibitions on a regular basis, display traveling exhibitions and individual works borrowed from collectors and other institutions, and are often capable of exhibiting only a part of their permanent holdings.

To decide what background to present, consider the kind of information that can help students to become familiar with the works of art, to understand the concepts embedded within them, and to develop opinions about them. Depending on your schedule and resources, you might decide to show slides or reproductions of works that you will see and share descriptions of the special characteristics or relative importance of individual works.

Although the art curriculum should be the starting point for directing the museum experience, the options to help you get the most from a field trip are wide ranging. You might take the opportunity to describe other art or artists from the cultures or time periods covered by the museum. You might discuss cultural differences, artistic careers, or various art-making processes. This may be an excellent time to review previously taught material by relating it to works at the museum. For example, if a previous lesson covered printmaking, your visit could highlight Japanese woodcuts, works by Albrecht Dürer, or the prints of the Impressionists. Issues surrounding composition, texture, the use of color, or subject matter might serve as entry points. Or, you may decide to

devote one or two preparatory lessons to issues of art history, criticism, or aesthetics. In-class studio projects, writing assignments, group research, and role-playing activities can both dovetail with the art curriculum and help you to guide, inspire, and excite your class about an upcoming trip.

Ideally, such preparation will equip students to participate fully in gallery discussions. Prior knowledge will allow them to make connections between classroom instruction and the works they observe at the museum. Exposing students to ideas and concepts that will assist them in understanding specific works will also deepen their knowledge base of art in general. Art teachers need not do all the preparatory teaching themselves. As previously discussed, museums offer a number of invaluable resources and services that can be used for background preparation. And museum educators are themselves excellent resources; you might consult them for additional ideas and assistance in preparing your students.

Museum Worksheets

A museum visit may not be limited to a guided or self-guided tour. In addition to the activities described earlier, students might also use museum worksheets. These are useful tools for encouraging students to carefully observe works of art. Museum education departments may offer worksheets, or may assist you in creating your own in advance of the visit.

Museum worksheets are relatively easy to develop and are useful in a number of ways. For example, they can help students recognize the importance of labeling. When labels include language and ideas understandable to students, they may become entry points for learning opportunities. Worksheets can help to focus students' attention on specific works or to assist them in recognizing connections between

works they have previously studied and those encountered at the museum. Students also may use worksheets to collect information and to record ideas for future classroom discussions or projects. Worksheets may support other activities and instructional experiences planned for the visit, such as gallery games or role-playing activities.

To develop a worksheet meant to focus student attention on a few specific works, first decide upon one or two "big ideas" that you want the visit to emphasize. Then, select five to eight works that are linked thematically, stylistically, or in some other way, to help you achieve your goal. Choose works that are relevant to your art curriculum goals and make sure that the works are currently on display. Selecting a small group of works will allow students to study each work in greater depth. A basic worksheet might include the following points:

- a list of each work by title, artist, date, and medium, as well as information about where the work originated (and other pertinent information from museum labels, if suitable)
- enough contextual information to help prepare students to learn about the works
- descriptions of any characteristics that you wish students to observe
- five or six questions to help students arrive at the intended "big idea(s)"

You can also develop worksheets that incorporate a wide variety of activities including interdisciplinary connections like poetry writing or math problems, as well as games like scavenger hunts. To be successful a worksheet should be clear, concise, and easy to follow. Provide enough room for students to record their thoughts and findings. Also, make sure that you are aware of the museum's policy regarding the use of writing utensils (for example, students may be limited to writing with pencils while in a gallery).

Museum Activity

Director's Choice

Students play the role of an art museum director. They must decide which work(s) of art they would choose as the highlight of the visit. Students complete a worksheet to justify their selection and collect information.

Art Survey

Students identify a select number of pieces belonging to a certain category (e.g., style, theme, or time period). Students (individually or in pairs) work in one gallery only to complete a worksheet that encourages them to critically observe the works.

Post-Visit Activities

Studio Options

Students might complete one of the following activities.

- Design a bumper sticker to inform members of the community about the museum, its value, and what it contains.

- Create a map or floor plan of the museum or gallery that identifies landmark works and special features.

- List some examples of different ways of making art that they saw in the museum. Then invite them to find out more about one of them.

- Think about one of their favorite works from the museum, and create an original work based on this subject.

- Create an artwork that depicts something that happened at the museum.

Fine-Tuning Your Plan

Once a museum visit is organized, refine the established plan in order to maximize success. Fine-tuning your plan does not mean making drastic changes; it means thinking abut the factors that could subtly influence students, then making modifications as needed.

For example, students may have expectations for a field trip that can affect how they learn in the museum setting.[6] These expectations can be thought of as student-centered agendas. Students generally have two types of expectations: an ideal agenda and a realistic agenda. The ideal agenda is made up of students' hopes for the trip. This may include seeing an exciting, interesting, or favorite work of art or perhaps simply visiting the gift shop. The realistic agenda is more in tune with the teacher's plan for the museum experience—obtaining information and learning. When teachers address the student-centered agenda by providing information about what will happen during a museum visit, they are better able to influence student learning.

A familiar phenomenon called "museum fatigue," associated with overexposure to stimuli, is also a real concern for students. Overstimulation can tax students and reduce their ability to concentrate. Also, extended periods of time looking at art and listening to verbal information can result in boredom and overload, draining students' energy and decreasing their capacity for learning or absorbing data. Careful thinking about what students will see and do while at the museum can help you to find a balance appropriate to your class. Too much art looking can actually be counterproductive to your long-range goals; students who experience museum fatigue may wish never to cross the threshold again. Planning just the right amount of time at the museum and focusing

on a careful selection of works can greatly contribute to a visit's effectiveness.

Before you depart from school, take time to review your plans one last time to make sure things run smoothly. Even the best laid plans can go awry, and you may have to make adjustments to your plan while at the museum. But remember: try to enjoy your time with students as much as possible throughout the trip. If you let students see your enthusiasm for a visit to this special setting, it will help them recognize their own eagerness and set the stage for a special experience.

After the Visit

In-class instruction following the field trip can help you fully realize your teaching goals and capitalize as much as possible on the visit. Post-visit activities can deepen understanding of both the works seen and the museum itself. A number of activities may be worthwhile at this point. For example, if students saw a well-known sculpture or other work of art, you might have them read reviews of the work. You also might have students read excerpts from an artist's biography or autobiography. As a class, you might look at reproductions of other works by an artist and discuss the influences, symbols, interpretations, or other aspects of the works that become apparent through comparing and contrasting them. To further extend the lesson, students might create a timeline of an artist's life and career, identifying important contextual events that coincided with the artist's life. As a related studio project, students might create artworks by using techniques or media similar to those seen at the museum. A variety of assessment activities may be employed to ascertain the extent to which students learned what was intended by the visit.

Post-Visit Activities

Writing Options

- Students use newspaper clippings, books, or the Internet to research and report the history of the museum.

- Students complete a worksheet that asks questions about a specific work they studied during the visit.

- Students select a work and develop a scenario about how it might have become part of the collection. They may or may not include factual information about the artist or appropriate time period.

Teacher Talk

Patricia E. Johnston, a high school history and art-history teacher at Pineview School in Sarasota, Florida, recalled a trip to The John and Mable Ringling Museum of Art. "We were there about three weeks ago, and the focus . . . is on how the different paintings fit in with the historical periods and how you can tell about the history from the art. Usually artists are way ahead of everybody else. They really have a sense of the period . . . they do say a lot about the society. We go to the Ringling especially after we study the Renaissance and the Reformation and they have all these paintings that have to do with the Counter-Reformation or the Catholic Reformation. So it really fits in very nicely. Everything that they've learned in their history class they can see in the original art."[7]

The Power of the Museum

"One often meets successful adults, professionals or scientists who recall that their lifelong vocational interest was first sparked by a visit to a museum. In these accounts, the encounter with a real concrete object from a different world—an exotic animal, a strange dress, a beautiful artifact—is the kernel from which an entire career of learning grew. For others with an already developed curiosity about some field such as zoology, anthropology, or art, the museum provided an essential link in the cultivation of knowledge—a place where information lost its abstractness and became concrete. In either case, many people ascribe powerful motivation to a museum visit, claiming that their desire to learn more about some aspect of the world was directly caused by it."[8]

—Csikszentmihalyi and Hermanson, 1995

The following list offers a few possibilities for post-visit activities.

- If students viewed a collection of nineteenth-century sculptures, they might compare and contrast them with the works of twentieth-century sculptors, such as Louise Nevelson, Eva Hesse, and Barbara Hepworth.
- If students studied a collection of landscape paintings by artists such as Thomas Moran, Albert Bierstadt, and Thomas Hart Benton, they might create their own landscapes using local scenery as their inspiration.
- If students observed objects such as Art Nouveau jewelry, American art ceramics, or Native American textiles, you might ask them to compare the works to similar objects created by artists from a different culture—for example, ancient Egyptian jewelry, Chinese ceramics, and Peruvian textiles.

Depending on students' knowledge base, such post-visit activities might involve some art-historical research, include a discussion related to aesthetics, or direct a writing exercise that incorporates art criticism. Your art curriculum can guide your decisions. See the Appendix, page 113, for a helpful checklist of ways to incorporate your museum visit into the artroom.

Conclusion

This chapter has examined the museum visit as an important instructional experience. When teachers prepare students by linking the classroom and the museum and by orienting them to the setting and the works they will view, they are establishing students' capabilities for meaningful learning. Museum education in both an art classroom and in a gallery setting may be planned in a variety of ways and

need not include a set menu of choices. Rather, the art curriculum, teacher's imagination, and students' interest should all play a part in deciding how to best instruct the class before, during, and after a museum field trip. Furthermore, museum educators should be thought of as valuable contacts and partners in developing these important educational opportunities for students. These professionals can assist art teachers in making meaningful educational decisions about both in-class and on-site instruction. Together, the two can ensure that students have a rewarding and eye-opening experience that they will remember for the rest of their lives.

Notes

1 Teri Brudnak's letter appeared in the on-line discussion forum ArtsEdNet Talk on November 18, 2000. Reprinted with permission.
2 John H. Falk and Lynn D. Dierking, *The Museum Experience*. Washington, DC: Whalesback, 1992.
3 Personal interview with teacher in 1997.
4 Ibid.
5 Elaine Clayton, *Ella's Trip to the Museum*. New York: Crown Publishers, 1996. Diane Stanley, *The Gentleman and the Kitchen Maid*. New York: Dial, 1994.
6 Falk and Dierking.
7 Personal interview with teacher in 1997.
8 Mihaly Csikszentmihalyi and K. Hermanson, "Intrinsic Motivation in Museums: What Makes Visitors Want to Learn?" *Museum News*, 1995. Vol. 74, #3.

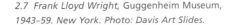

2.7 Frank Lloyd Wright, Guggenheim Museum, *1943–59. New York. Photo: Davis Art Slides.*

Bringing the Museum
to the Classroom

"…Try to think of how [the museum] can fit in with the curriculum that you have…So, first you need to know the museum really well so that when you finally do approach the people there, you know what you're talking about, and have a few ideas of what could be done." [1]

—Patricia E. Johnston, high school history teacher

Art teachers inevitably bring the museum to the classroom. They routinely show and discuss reproductions of works housed in collections around the world. They also talk about artists whose careers, achievements, and reputations are often affected by (and sometimes even result from) museum collections and special exhibitions. Art teachers also may mention institutions whose collections are internationally famous. But how can teachers address museum-related issues on a regular basis? And how can these issues be integrated in a way that is meaningful and relevant to students?

Try This

Students discuss the idea of a museum for their class including artifacts to be collected, a mission for their museum, and their goals. The mission is posted and students organize and manage a "museum" based on this statement. Assign curators for certain parts of the exhibit and have students write labels for the exhibit. Or, students might identify a rotating board of trustees, director, and curator and receive credit for their work in these roles. (See also "Create a Classroom Museum," on page 49.)

3.1 Art teacher Joyce Huser involved her students in developing a school "museum" using reproductions. Students visited the museum and completed a worksheet. They paid an entrance fee to visit. The museum café offered snacks.

Integrating the Art Museum

No one would argue that museums not only offer unique opportunities to view original works of art, but they can also offer a lot more to classroom education. Museums can provide the perfect introduction to the broad sphere of activities known as the "art world." In addition to the works of art, this world includes viewers, supporters, experts, critics, historians, collectors, preservationists, and the artists themselves. Museums play an active role in this world—largely by acquiring, exhibiting, and preserving art.

One way to have students become familiar with the diverse world of art that exists outside the classroom is to help them to understand how museums contribute to it. As institutions, museums help to define art and to provide works with a historical and cultural context. Museum activities, by their very nature, set selected objects apart from others, thereby giving those objects a certain status.[2] As museum staff members make aesthetic decisions, they become arbiters of taste and values. Art museums reflect changes that occur in society. Unlike, for example, a historic home, an art museum is not a time capsule; it is a dynamic and constantly evolving institution. Exposure to these and other aspects of museums can help prepare students for a lifetime of understanding, appreciating, and supporting the visual arts. Knowledge of these ramifications also provides students with a comprehensive view of art that they would otherwise lack.

Examining the museum in the classroom can help students to better understand the active role that members of a community can play in the art world. City officials and citizens often deliberate about issues that are essentially related to the realm of aesthetics. For example, it is not unusual for a town to commission a public work of art. Deciding which

artist to hire and creating guidelines for the work inherently touches upon issues of taste, values, and judgment. Another increasingly important example is the identification and support of local historical sites; many communities have older buildings that require restoration, or at least merit recognition for their architecture.

Bringing the museum to the classroom will enable students to become aware of questions that underlie these and other aesthetics issues. Students also will come to understand the existence of multiple perspectives, and why decisions concerning aesthetics often stir up controversy. Looking into the future, students may build upon this knowledge to develop informed opinions about similar occurrences in their own community. Furthermore, and perhaps most importantly, this awareness may also motivate them to become active participants in such debates. If one of the goals of art education is to assist students in developing an awareness of the "art world," then integrating a discussion of the art museum into the curriculum is a step in the right direction. And if one of the goals of general education is to relate learning and ideas to students' lives, then bringing the art museum to the classroom can help achieve that goal.

Four Classroom Approaches

In general, art teachers have a curriculum—an organized set of ideas and activities that represent educational goals for their students. As mentioned above, the museum is pertinent to this instructional agenda, and including it does not require a revamping of the curriculum. You may have to locate some additional resources to broaden your teaching materials, but, in general, teaching about the art museum simply capitalizes on what art educators already know and do.

The following sections present four possible entry points for integrating the museum into your art curriculum. These involve using reproductions, leading discussions based on the museums and their staffs, and taking advantage of art subjects that appear in the news. These approaches are complementary and offer productive avenues for extending current lesson content and developing new opportunities for instruction.

The Reproduction as an Entry Point

Educators typically have a store of reproductions with which to teach art, including slides, videotapes, posters, and so on. These images can also serve as entry points for initiating discussions about the museum. The mere inclusion of images in a lesson represents an opportunity to discuss museum-related issues and material. For example, if you show a reproduction of a Matisse painting during a lesson, you are also exposing students to a work that is part of a specific collection or institution.

The following is a list of questions that you might ask as part of your general classroom discussion.

- How can we find out which museum owns this work?
- Where is this museum located?
- Why do you think a museum might collect this piece?
- Where in a collection would this kind of work be placed?
- What special steps might an institution take to care for such a work?
- What other museum(s) might house similar works?
- What unique aspects of this art might only be fully appreciated by seeing the work in person? Why?

Discussion Point

Museum Design

Architects must work closely with museum staff, patrons, and museum trustees when developing ideas for museum architecture. The relationships and consensus among these individuals determine the resulting design and gallery spaces.

The following questions could be examined in the classroom:

- Should architects have the freedom to create their own designs?

- Why are patrons important to the architecture plans undertaken by a museum?

- Which individuals might best be cast in the role of critics of an architect's work?

- In what way(s) is the community important to the design of a new museum building?

A book by Victoria Newhouse, *Towards a New Museum* (1998, Monacelli Press), may also inspire some interesting discussion points concerning the design of museum buildings.

Queries such as these can be inserted into a discussion spontaneously. Your ensuing dialogue about the museum can be brief or extended, as is appropriate to your needs.

Reproductions might also be used to develop specific lessons that focus on issues related to the art museum. For instance, a printmaking lesson that highlights the works of Albrecht Dürer might lead to another lesson on how museums display, store, and care for prints. When viewing several reproductions by the same artist, explain that a museum might have many, some, or only one work by a particular artist. For example, the Museum of Fine Arts in Boston has several paintings by Claude Monet. A discussion prompted by this type of information could touch upon a number of possibilities, including the fact that a benefactor may have acquired artworks because of personal taste or interest; or, that an institution may have had the resources and opportunity to purchase several pieces by an artist, thereby giving greater depth to the collection. You might extend such a lesson by having students investigate a local museum to discover the history of a specific collection. This material might also involve an exploration of the aesthetics issues behind the genesis of a collection. Have students discuss the advantages and disadvantages of a museum owning more than one work by an artist.

The table on page 114 of the Appendix presents examples of lessons relating art education to the art museum across the disciplines. Lessons are presented within three different types of curriculum focus: artistic form, theme, and style/period. Expand and modify these examples according to your instructional needs. In essence, this approach provides a way to take full advantage of the art curriculum you already teach, through using reproductions.

The Museum Itself as an Entry Point

Art museums are complex and multifaceted institutions that offer great potential for classroom instruction. In addition to the actual collections, you might explore a museum's history, benefactors, diversity of functions, architecture, or even its ongoing or unique relationship with a specific artist. Focusing on these and similar dimensions can reveal the intricacies of the museum as an institution. By viewing an art museum in this way, you can also transmit to students a more in-depth view of cultural institutions in general.

One example of this approach is a lesson that covers the reasons why a museum might collect certain types of works, such as Asian art, modern paintings, or Mesoamerican pottery. This topic naturally touches upon one of the key functions of a museum: collecting. As part of the lesson, you might invite a local collector or curator to discuss her or his collection. The speaker could talk about the reasons for collecting and the criteria behind making a purchase. The lesson could help students understand the differences between a private collection and one housed in a museum. You might even ask student volunteers to bring in and talk about objects from their own collections, or to write an essay explaining what they value most in a collection.

Another lesson might examine a well-known institution through research gathered by students. Such a lesson might rely on information from the Internet

3.2 Bernard R. Maybeck, Palace of Fine Arts, 1915. *San Francisco. Photo: Davis Art Slides.*

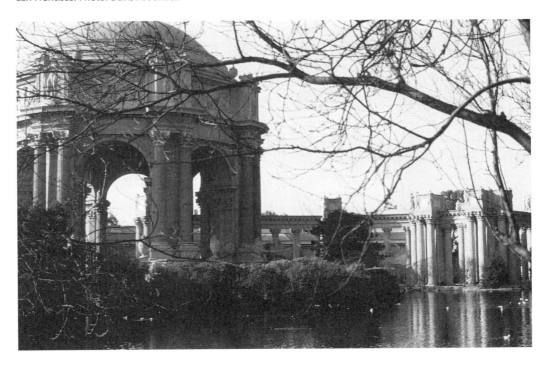

Try This

Students organize a special exhibit of their own art accompanied by a catalog with essays. Students might take photographs of their work and include them in a catalog (this may be part of a book-making studio project). You might display copies of the student catalog in the principal's office, at a parent-teacher meeting, or in classrooms or the school library for others to read and enjoy.

Teaching Ideas

Read *Victor and Christabel* (by Petra Mathers)[3] to young students. The book is a delightful story about a museum guard named Victor. He is taken with a special painting, *Cousin Christabel on Her Sickbed*. The guard falls in love with Christabel and begins to uncover the mystery of the painting. The story provides an interesting way to begin discussing the various professionals who work at museums.

Teaching Ideas

Read Mike Dickinson's book *Smudge*[4] to young students as a way to begin discussing the museum's role in safeguarding and preserving art. The main character, Smudge, finds mischief in a museum. During his adventures, he roams in and out of paintings, vases, a mummy case, and other works. Smudge also visits the museum basement where all kinds of artworks are repaired. There, he ultimately finds a new home in a painting with the help of the museum conservator.

and other sources. It might culminate in a class report, presentation, or display about the chosen museum. Many museums, even smaller institutions, have fascinating histories. One is the Yellowstone Art Museum, which is housed in a former county jail.[5] A larger one is the Louvre, originally a fortress and then a palace. The Winterthur Museum, a former country estate, houses the earliest collection of American decorative arts.

A lesson that focuses on a museum's architecture is also rich with possibilities. Many museums can be viewed as works of art in themselves, with various architectural elements worth attention and study. Architectural styles, elements, and decoration can serve as sources for art education instruction. You might explain that museum staff, community members, and even patrons may work with an architect to make aesthetic decisions. A visit to a local museum might offer an opportunity to view original architectural plans or blueprints, which can lead to a discussion of the ideas behind such plans as well as comparisons to later additions or alterations. As part of the lesson, you could ask students to design their own museum or create a model of one they have studied. One possibility is to plan a class competition in which pairs or groups of students design a museum according to certain criteria. Examples to focus on might include the Centre Georges Pompidou or the Museé d'Orsay in Paris, the Guggenheim Bilbao, and the National Museum in Rome (partially housed in the Baths of Diocletian).

"Dimensions of the Art Museum" on page 115 defines and illustrates further lesson ideas. You may also choose to extend an existing studio, art history, criticism, or aesthetics lesson by considering some of these issues.

Museum Staff Roles as an Entry Point

Art museums include staff members whose responsibilities make possible the ongoing operation of the institution.[6] A museum's size will usually determine the size of the staff and the scope of their responsibilities. Such information about the professionals who work at museums can further enhance students' knowledge about how museums function.

The following is a list that describes the roles of various museum professionals. You might incorporate this information into lessons. For example, you might ask students to role-play various positions. They might assume roles to debate aesthetic issues, such as the acquisition and deaccessioning of objects as well as the repair and exhibiting of individual works. Or, they may become curators, directors, designers, and security guards for their own exhibitions.

Director: The director is in charge of the museum. He or she works closely with its governing board (trustees, directors, etc.) to plan for the future of the museum. This may involve raising money and obtaining political and community support for the institution. The director also provides important leadership for the staff, expedites museum business, and makes decisions about exhibitions and the purchase of art, among other duties.

Curator: A curator has extensive art-history training and oversees the collection(s) of a museum. This professional studies the works to learn more about them, decides on their display and placement, and looks for potential acquisitions to supplement an institution's collection. In addition, this professional organizes special exhibits and writes the accompanying catalogs and labels for displayed works. Larger museums often have many curators, each responsible for a certain type of art or curatorial department.

Educator: This professional might be a volunteer guide, gallery teacher, or museum educator. These staff members educate the public about art by giving tours and gallery talks. They also may assist in the writing of labels and the creation of other written materials.

Conservator: This expert employs scientific knowledge and equipment to inspect, clean, and repair works of art. He or she uses special techniques to protect and extend the life of individual objects, thereby preserving a museum's collection. The expertise of a conservator permits her or him to work with a variety of materials, such as paper, metals, textiles, and canvas.

Registrar: The registrar keeps careful records of a museum's collection. He or she must be aware of works that are in storage, on display, on loan, and borrowed from collectors or other collections.

Designer: Designers create plans for exhibition space. These plans usually involve layout decisions, color choices, exhibition cases, and other display considerations. These professionals also design posters, pamphlets, and gallery signs.

Photographer: This professional's job is to photograph the works in a museum's collection, especially new acquisitions. A photographer uses sophisticated equipment to accurately record the visual appearance of objects.

Security Guard: A guard protects works on display to the public. In addition, this staff member directs visitors around a museum's galleries. After hours, guards check the museum for the safekeeping of the collection.

Librarian: The librarian cares for the books, serials, monographs, exhibition catalogs, and related materials concerning a museum's collection. In addition, this professional provides assistance to museum staff, researchers, and teachers.

Did You Know?

Lending institutions take painstaking efforts to ensure that works are transported safely and without mishaps for traveling exhibits. They also must be sure that works are carefully handled and displayed as well as protected during exhibition. Institutions that borrow art for special shows invest large sums of money for liability and protection coverage when borrowing works.

An example of this kind of protection is the preparation undertaken for a Van Gogh exhibit at the National Gallery of Art. The Van Gogh Museum in Amsterdam loaned seventy paintings to two U.S. museums. The museum staff left the wooden carrying cases inside the museum for at least twenty-four hours before crating the works that were to travel. This allowed the cases to become acclimatized to a temperature of 66°–70°F, which helped protect the paintings from temperature shock.[7]

Maintenance Workers: These technicians clean a museum after hours. Their responsibilities cover a wide variety of tasks, such as dusting art, cleaning floors, and so on.

Craftspeople: A museum may use the services of carpenters, plumbers, electricians, and other skilled workers depending upon its size, needs, and resources.

In addition to being an enjoyable way for students to extend their understanding about museums, this information can provide them with knowledge about career opportunities. Students who do not wish to pursue an artist's path might find any number of these possibilities appealing. You might invite museum professionals to discuss their responsibilities and academic background with your class. Such instruction also helps students see the museum as an approachable and active part of the community.

Art in the News as an Entry Point
Current events related to museums and the art world are excellent entry points. Articles in art journals and magazines, from the Internet, and even exhibition catalogs are all possible sources. Of course, television and daily print media are also readily available. Television news and newspaper articles often cover national and international incidents and developments about museums. They yield numerous pieces of information about new acquisitions, stolen works of art, and recently discovered forgeries.

Art topics covered by the news media may prompt classroom discussions, writing assignments, studio projects, and other types of activities. Educators can relate this information to instruction and expand upon it in various ways. You might create a classroom file to be used throughout the school year and rely on students to actively collect examples. Or you may establish a bulletin board to display

news items that might inspire classroom discussions, activities, further research, or even a field trip. Your art curriculum can help you to decide how best to utilize the collected information.

One of many examples of a relevant news item is a gift of a small, oval Pablo Picasso painting, *A Glass on a Table*, to the Corcoran Gallery of Art.[8] The benefactors, Wendy Leeds-Hurwitz and her family, donated the work, which is the collection's only painting by Picasso. Upon acquiring the piece, the Corcoran displayed it alongside a Picasso etching entitled *The Frugal Repast*. Even this scant information can inspire classroom instruction. For example, students might discuss what can be learned by pairing an etching and a painting. This in turn might lead to an explanation of what curators do. Students could then research the staff of a local museum and identify other important positions. The news might also be an entry into a discussion of Picasso's place in twentieth-century art or a discussion of the Corcoran and other museums in the Washington, D.C., area— the possibilities are many.

Another example, from the *New York Times*,[9] is a review of the exhibit "Little Dancer Aged 14." This show, at the Sterling and Francine Clark Art Institute in Williamstown, Massachusetts, featured only one work, a well-known Degas sculpture. Students could brainstorm about what might be learned from a single-object exhibit. They could then read the review and continue adding to their list. The review might also prompt research into Degas' career or other famous sculptures of the nineteenth and twentieth centuries. You could ask groups to select one well-known work, thoroughly research it, and then report their findings to the class. The class might even develop their own exhibit based on a favorite work of art.

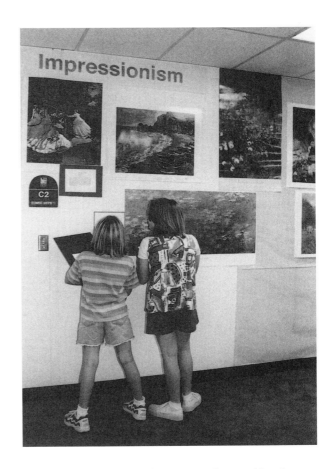

3.3 *Valley Park Elementary students studying the school "museum." Teacher: Joyce Huser.*

Discussion Point

Single-Artist Museums

Today, more than 400 single-artist museums exist around the world. Many are located in the United States, but only one is devoted to a female U.S. artist with a national reputation. This is the Georgia O'Keeffe Museum, which opened in Santa Fe, New Mexico, in 1997.[10]

The following questions may be used to focus student discussion:

- Why might a museum be devoted exclusively to one artist?

- Do you think that O'Keeffe is more important than other artists who are on view in other types of museums? Why or why not?

- What makes an artist important?

- What factors contribute to an artist's fame and reputation?

Try This

Have students share their ideas about what life might be like later in the twenty-first century. What kind of art museum might best accommodate the needs of this century? What technological advances might help museums reach more people? Should museums reorganize their collections? Should they be managed or influenced by others in addition to art historians? Ask groups of students to develop a set of sketches to reflect a new art museum of the twenty-first century, including designs for both the exterior and interior.

Links to the Art Disciplines

The four disciplines of art might themselves be starting points for classroom instruction about the museum.

Aesthetics

Aesthetics issues abound when it comes to discussing the art museum. Topics such as the role and function of a museum, its collection, its viewers, and the relationship between a community and a museum can all lead to exciting questions and ideas.

Here are a few examples of aesthetics questions that you might explore, related to the art museum.

- What do you think art museums should collect?
- Why do some museums collect only certain types and forms of art?
- Why might certain works in a collection be valued more highly than others?
- What should a museum look like? Why?

By examining these ideas and others, you can easily establish connections between your art curriculum and a field trip to a museum. Exploring such topics can expose students to a variety of famous and lesser-known works, help them form their own judgments, and also offer opportunities to analyze the judgments of others.

Art Criticism

Art criticism instruction can be integrally linked to a museum visit. The following list offers some suggestions for classroom activities.

- Ask students to describe, interpret, and judge works of art that they see during a field trip.
- Have students read newspaper or magazine reviews of a work or exhibit and then compare those reviews to their own observations and opinions.

- Lead students to an understanding of the relationship between an artist's intentions and the interpretation of a work as presented by the museum. To accomplish this, you might have students read an artist's statement, develop their own descriptions of the work, and then devise original interpretations of a piece. Compare their interpretations with that of the museum, discussing possible reasons for differences or similarities.
- Before your visit, invite students to write a response to a reproduction of one artwork that they will see. Students can then compare this initial response to one prompted by seeing that work in person.

Studio Art

Studio art activities dovetail well with museum visits. The following descriptions offer a few possible options of process-related, style-related, and artist-related projects.

- Have students create pieces using the same or a similar process as works they viewed in a collection. For example, if you observed an exhibition of prints, instruct students in one of the printmaking processes reflected by the collection.
- Have students create a work in a style similar to works from the collection. For example, if you looked at watercolor landscapes by Georgia O'Keeffe, students might paint their own landscapes paying special attention to abstract qualities, color, shapes, and forms. They also might experiment with a loose application of watercolor.
- Have students create a work in response to the work(s) of a particular artist seen in the museum. Have them sketch one piece, develop an interpretation of the piece, record some ideas or concepts reflected by the work, and, if feasible, read some background information. In essence, students

Discussion Point

What Qualifies as Art?

The Solomon R. Guggenheim Museum featured "The Art of the Motorcycle" in 1998. This show included more than 110 motorcycles in a museum known for its collection and exhibition of great works of art.[11]

The following questions might be used to initiate a classroom debate.

- Are motorcycles works of art? Why or why not?
- Why might an art museum deviate from the types of art that it usually displays?
- If a motorcycle is a work of art, what other kinds of things can be considered art?
- How might the way a motorcycle is displayed help viewers to think of them as works of art?

Discussion Point

The works in an art museum are often referred to as masterpieces. Ask students to define the word *masterpiece*. List the big ideas of their definitions on the chalkboard. Show them several reproductions of artworks considered by experts to be masterpieces, highlighting those characteristics that make them noteworthy. Do students consider these works to be masterpieces? Why or why not? Discuss the contributions of these works to the history of art, referring to the list of definitions created by students. Ask whether their definitions need to be modified and if so, in what ways.

What Should a Museum Do?

Explain to students that many people have ideas about what museums should and should not do. Robert Motherwell, a famous twentieth-century painter, had some strong opinions on this topic. Among his statements, he said the following:

"I would love to go to San Francisco, say, to see all the Matisses, to Cambridge for the Sassettas (if there are that many), to Chicago for the Goyas, to New York for the Rembrandts, to Merion for Renoirs, to Washington for Titians, to Philadelphia for cubism, to Boston for Greek pots; or to any small town to see all of a minor artist."[12] Ask students: Is this possible or desirable? What might be gained by such offerings? What might be lost?

Try This

When the class is studying a culture as part of their social studies curriculum—for example, Egyptian, Greek, Syrian, Korean, or Native American—have them investigate the kinds of artifacts that are related to their chosen topic. Students then develop an exhibit representing that culture. They may research exhibit catalogs and the Internet or visit a local institution to find out how museums develop such exhibits. Students might plan an opening night for their exhibit and give guided tours for parents and peers.[13]

become "experts" on that work. They can then respond to the work in some way—either to the imbedded ideas, style, or subject matter. Students can choose their own artistic process, materials, and tools. For example, if they focus on a painting, they might create a piece of pottery as a personal response. They might also write an artist's statement for their work.

Art History

There is much potential for instruction that links art history with the museum. Because the art museum is not just a collection of objects, topics of broad perspective are possible. Of course, you can focus on the collection itself, but you also might choose to view the organization of exhibits and galleries, the methods of display, or how the permanent collection reflects taste, ownership, and values.

Here are some possible classroom activities:

- Have students create a classroom exhibit that simulates how a collection is organized—for example, according to style or period.
- Ask students to create their own labels for specific works that highlight an artist's style and influence.
- Have students (or small groups) select a work or artist to investigate so they can become experts. The class can then create a timeline of the works studied.
- Have students work independently (or in small groups) to investigate the cultural context within which a particular artist worked or within which a particular work of art was created.

Cross-Curricular Links

This section highlights the work of two classroom educators who have developed approaches for integrating art with other areas of study. Such connec-

tions extend traditional thinking about the role art can play in general education. These vignettes also offer ideas for working more closely with other classroom teachers, building a tighter web of art education connections throughout the school curriculum, and bringing the museum to the art classroom.

Social Studies

Linda L. Weinert, a fifth-grade classroom teacher in Omaha, Nebraska, utilizes the Joslyn Art Museum's resources when teaching social studies. She states, "I have really come to appreciate the worth of actual works of art to the curriculum that I'm teaching." Weinert targets a part of the museum's collection and integrates those pieces into her classroom plan. To help her do so, she relies upon two of the museum's Outreach Trunks.

During the first part of the school year, Weinert's class studies the history of the United States, focusing on Native Americans. At this time, the class uses the Outreach Trunk "Peoples of the Southwest and Plains American Craft Traditions." The trunk contains examples of Native American artifacts such as pottery, weaving, and basketry.

During the second half of the year, the class uses another Outreach Trunk, "Views of a Vanishing Frontier: Bodmer-Maximilian Expedition 1832–34" to explore ideas and issues revolving around the Westward Expansion, which occurred between 1800 and 1860. Explorers' records of the West—maps and drawings from the travels of Prince Maximilian and Karl Bodmer as well as information about Lewis and Clark's expedition—provide a view of Native American dress and lifestyle. Along with Native American cultural information, the records show the natural environment of the time. In addition, Weinert's class examines paintings by artists such as Albert Bierstadt, George Caleb Bingham, and

Thomas Moran. These works include depictions of natural beauty in the unexplored West.

As a related studio project, Weinert has her students create drawings and paintings to help them establish a personal link with history. For example, students explore the beauty of nature by painting landscapes based on sketches done in local neighborhoods or in a nearby state park.

Language Arts

Emily Barry Marston, a middle school teacher at the Philadelphia School, uses the Philadelphia Museum of Art to help her integrate art and language arts. The school's curriculum revolves around rotating themes, such as ancient civilizations or the Renaissance. These themes are studied from various perspectives, including the study of primary sources. Students' reading assignments may include diaries, notebooks, and fictional works.

Students are also exposed to images and artifacts from the period. According to Marston: "Artifacts encode the sorts of stories we want to share with children. And so that constantly brings us to the source of these artifacts—museums." Field trips are planned at least three times a year depending on the themes examined, and these museum visits become the basis for in-class research activities.

Marston works closely with museum education department staff, who indicate aspects of special exhibits or the permanent collection that can dovetail with her language arts instruction. Museum educators also provide materials, such as posters and slides, to support classroom instruction. As a culminating activity, students write a work of historical fiction. One goal of this activity is for students to use authentic details, such as characters and settings inspired by the museum's collection.

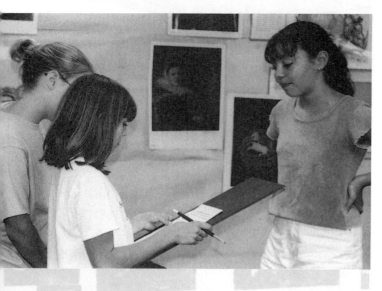

3.4 Students at Valley Park Elementary considered and discussed concepts about exhibited reproductions in their school "museum"; they completed a worksheet to demonstrate their knowledge.

Adopt an Art Museum

A meaningful way to highlight the museum is to adopt one. The word *adopt* signifies establishing a relationship where none previously existed. Adopting a museum can be a formal or an informal arrangement. An important factor that determines the parameters of a museum adoption is the proximity of the institution. If the museum is accessible, this allows personal contact for the teacher and museum visits for the students. However, distance need not deter the adoption of a museum. In fact, an institution located at a great distance can be made real for students through art education instruction.

Consider adopting an art museum for a week, a month, or even for one school year. Your curriculum content might fit with a museum's collection. Art instruction could provide in-depth study of works at different points in time. You could display reproductions of the collection, photographs of the museum's exterior, and brochures of museum events and offerings. Students could be involved in obtaining these by telephoning or writing to the museum. Museums routinely publish catalogs of collections with informative essays and descriptions; such materials may be available through a public library or directly from the institution.

You might identify a museum of interest by using *The Official Museum Directory*, published by the American Association of Museums. This directory offers a nationwide listing of art museums with descriptions of their collections. Most medium and large public libraries have a copy. Next, consider a museum's collection and ask such questions as: Are there many overlaps between our curriculum and the museum's collection? Is there an institution that offers avenues for exploring new material in the classroom? Might there be a museum that includes

works that could be infused throughout a unit of study? What are students' interests? How could the museum become part of the artroom?

An Adoption Example: The National Portrait Gallery

The National Portrait Gallery is part of the Smithsonian Institution. Its permanent collection represents individuals significant to United States history.[14] The gallery has a dual role as an art museum and as a history museum. Its portraits—including sculptures, paintings, drawings, prints, and photographs—are created by important artists, but they also offer a visual version of United States history. The collection includes images of presidents, leaders in science, education, and industry, as well as famous composers, artists, writers, performers, and other heroes. Thus, the historical story is also about people whose achievements and contributions cut across many fields.[15]

The National Portrait Gallery might serve numerous needs of an art curriculum. Portraits offer a glimpse into a time period and culture. Thus the collection can, for example, support a general study of portraiture, which dates back to the Egyptians and Greeks. You might cover how the tradition of creating portraits has evolved through history. Visual materials can be used to instruct students not only about artists and their accomplishments, but also about technique, conventions, stylistic impulses, media, symbols, and other concepts.

The following chart represents some general areas of study, taking into consideration both the topic "portraits" and the specific collection of the National Portrait Gallery.

Topic Ideas

Types of Portraits	Conventions	Time Periods
Miniature	Size	Colonial Era
Formal	Pose/Expression	Early American
Silhouette	Technique	Early 19th Century
Group portrait	Composition/Grouping	Turn of the Century
Informal/Intimate	Costume/Clothing	Early 20th Century
Self-portrait	Background/Interiors	Post World War II
Abstract	Color	Modernism

Artists whose works are in the National Gallery's collection include Andy Warhol, Alice Neel, John Sloan, John Singer Sargent, Edward Hopper, Mary Cassatt, and George Catlin. Each has an individual approach to depicting sitters. Another point for discussion, then, might be the way that artists reveal information about themselves and their intentions as they show the personality and contributions of the individuals they portray. Students also could study the collection and then create their own portraits.

Lesson Ideas

Well-Known Subjects

Students study the portrait of a well-known person to identify how the artist's approach—such as the use of mood, color, and pose—determined his or her intentions. Some possibilities are the portraits of Robert F. Kennedy, Mary McLeod Bethune, Thomas Edison, Mark Twain, George Gershwin, Golda Meir, and Aaron Copland. Students could research the person portrayed and try to obtain a photograph of the subject. Later, students might develop a portrait of the subject using their own approach.

Try This

Collect postcards or other small reproductions of art. Have students adopt one work for which they write a label. This reproduction then becomes part of the classroom's "permanent collection." Students learn the meaning of this term and also about various methods of displaying/organizing such collections. When finished, the classroom display might be used to inspire student activities. For example, students might be paired to develop a tour based on a theme, time period, art form, or culture. Students could then take administrators, parents, or other students on their "tour" of the collection.

Revealing Portraits

Have students examine the way in which a subject's interest or career is revealed, perhaps through the inclusion of an interior space, background, or with objects and accessories. Middle and high school students can develop a portrait of a friend, family member, or famous person in a specific place and pose with objects representing interests, personality, and profession. Younger students might develop a story about a portrait they studied in which they describe the work (aesthetic elements), the person and her or his life, the setting, and events before and after the creation of the portrait. They then could create their own portrait of the person in which they reveal additional details of the story.

Self-Portraits

Assign students to study several self-portraits to look at artists' poses, expressions, and self-revealing elements, as well as the use of color and other characteristics. Possibilities include Thomas Hart Benton, Frank Duveneck, Lee Simonson, and William James Glackens. Each painting informs the viewer about personality, artistic attitude, and profession. Students can then create their own self-portrait, incorporating ideas and concepts observed in the artists' works.

Newsworthy Portraits

Middle and high school students might design a cover for *Time* magazine that features images of people who were noteworthy at a specific time in history. The National Portrait Gallery has all the original works (paintings, drawings, sculptures, and photographs) used on *Time* covers.[16] It is important to discuss with students that not all those individuals portrayed on the cover may be considered significant now (or in the future), but that they were important in some way when the issue was published. Lead a

discussion about the difference between individuals who are remembered today and those whose reputations were short lived. Students also might examine the approaches of the various artists. As part of the lesson, students might select an individual currently discussed in the media, design a magazine cover to highlight that person, and write a short statement to justify their choice.

These are only a few ideas that you might pursue as part of adopting the National Portrait Gallery. Educationally related resources can support teaching instruction. *A Teacher's Guide to Using Portraits* (1989, by Susan Morris), may prove especially useful. The author gives a framework with which to examine and decode portraits of all kinds and from many periods. The book also includes practical instructional activities.

Create a Classroom Museum

A classroom museum can be a valuable teaching tool. When students are involved in building a museum, they can become appreciative of and sensitive to some of the basic concepts surrounding such an institution. A classroom museum can be linked to art instruction in terms of exhibition themes, displayed works, and in other ways. The actual building of the museum might be accomplished through units, lessons, and student assignments. Not only can a classroom museum become integral to art education instruction, it can also be linked to subjects such as science, social studies, and language arts. It can draw attention to the art program, and serve to rally support from administrators and parents.[17]

Parents might become contributors in a number of ways by providing supplies, artifacts, or services. Administrators can be alerted to the potential uses of the museum and to its benefits to students. Constructing a classroom museum is most appropri-

Try This

Have students study a particular artist's work, concentrating on a five- to ten-year period of time highlighting at least ten works of art. Encourage students to focus on the artist's intentions, evolution, and achievements. The idea behind this instruction is to have students notice what they can learn about an artist when examining and studying a number of his or her artworks. Students can develop a bulletin board display that includes labels and a short summary about the artist, to be displayed alongside reproductions.

Discussion Point

Museums must carefully consider and study the frames of artworks because they form part of the works' image.[18] Curators spend time deciding whether frames are in good condition, are historically correct, and are suitable. Have students think about the works that will be displayed in their classroom museum. What works will be exhibited? What would be an appropriate frame for each work? Encourage students to consider shape, color, and texture. Provide them with examples of paintings that include frames.

Try This

Plan an exciting opening night for an exhibit. Design a special invitation (planned and executed as a studio activity) for parents, friends, and school staff. Students can volunteer for specific roles, including greeters, curators, docents, guards, and café staff. Find people willing to play music during the evening. Docents could practice with peers, who can provide them with feedback. Students could develop a short script for touring families and visitors through the artroom museum, highlighting art concepts. Have students interview museumgoers about their experiences, posing questions about what kind of art was seen, the nature of the family member's experience, and what attracts people to a museum.

*3.5 Harry Swartz, Untitled, 1998. Print, 3 3/4 x 3 3/4"
(9.5 x 9.5 cm). Grade 6, Centennial Elementary,
Lawrence, Kansas.*

ate for students in upper elementary and middle school grades. However, related tasks and ideas can be applied to a wide range of grade levels.

An important principle to consider when creating a museum is to start small with the idea of adding to the project over time. An after-school art club could become the vehicle for creating a museum. Or, several grades could collectively develop a museum with separate responsibilities given to each.

The Practical Issues
The starting point of the museum is fairly simple to identify. Where will the museum be located? Some feasible places are the library, an area near the school's entrance, the artroom, or some other special place that permits easy and comfortable access and traffic.[19] A non-school space could be also considered, such as a public library, an auditorium, or a municipal resource space.

Once the space is chosen, the next step is to assist students in identifying the nature of the museum and specific exhibit ideas. Explain to students that art museums are organized for acquiring, exhibiting, and safeguarding works and that museums are often established because collections and individual objects have been donated. The classroom museum might be organized for various reasons. For example, it might acquire and exhibit student works, or it could display objects found in students' homes. Students can discuss and vote on the possibilities.

Next, students should develop ideas for an exhibit. A teacher could describe the basis of exhibits and discuss some actual examples. If feasible, students could visit a local institution (an art or history museum) to examine existing exhibits, their design, labels and brochures, and issues such as lighting and the protection of objects.

You also might derive an exhibit theme from your art curriculum goals and objectives. Alternatives might be proposed for students to examine, discuss, and vote upon. Students also can contact museums for brochures, which could become central to the decision-making process. The following list offers starter ideas for an exhibit.

African Masks as Art
Artists and Their Self-Portraits
The Decorative Arts
Folk Art
American Paintings
Printmaking Processes
Wood, Stone, and Bronze Sculptures

Implementing a Classroom Museum Exhibit

A museum exhibit is a result of the efforts of various professionals, such as curators, designers, and educators. Students' participation in implementing an exhibit could parallel actual museum practice through the assignment of special groups. One group, for example, could work on the floor plan of the exhibit, considering traffic flow and the arrangement of the entire exhibit and its contents. Another group might arrange all exhibit materials and objects in their proper places. Yet another group could develop a brief script for tours given to peers, parents, teachers, and administrators. This information should amplify the information found in student labels. Once the exhibit is complete, the public can be invited. Parents, students, teachers, and the general public can visit the exhibit and provide feedback. A small number of students might be asked to observe museum visitors and to develop a revision plan based on their input.

Developing Exhibit Labels

As part of creating a classroom museum, have students write labels for their exhibit. This activity can be an important learning experience. Explain to students that labels are the written information that presents the themes and meanings of an exhibit. Such material is often found on gallery panels and walls. Inform students that curators devote much time to studying the objects to be exhibited in order to accurately interpret them. Students may be assigned one piece in the exhibit to research and interpret.

The sample worksheet on page 116 of the Appendix can be used to help guide students in writing labels. Once students complete their worksheets, they should exchange them to solicit feedback from their peers. Classmates should critique the labels, keeping in mind the viewer, and revise them accordingly. They should then copy the written information onto posterboard or a similar material to be used as part of the exhibit.

Developing Promotional Materials

Museums also devote time to designing materials that announce and describe exhibitions, and students should become familiar with this aspect of museum work. Assign various tasks to promote the students' classroom museum exhibit. These ideas can be modified as necessary:

- Develop a brochure about the exhibit that includes a few photocopies of displayed works. Include a brief description of the theme, the works on view, and the artists.
- Develop a catalog of the exhibit using bookmaking techniques. Students can learn how to design their own catalog so that it communicates the theme of the exhibit. Color photocopies of the works might be included, and students might

write expanded interpretations of the works on display.

- Write a review of the exhibit. Students could study examples of exhibit reviews written by critics and develop their own. Copies might be sent to local and school newspapers.
- Write an announcement of the exhibit for parents and newspapers.
- Create a calendar of exhibits for the year. Students could design artwork and develop text for the calendar. The calendar might be sold, and the proceeds used to support future museum exhibits.

3.6 Edward B. Green, Albright-Knox Gallery, *(detail), 1905. Buffalo, NY. Photo: Davis Art Slides.*

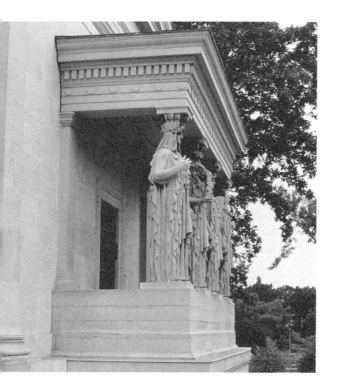

Conclusion

When teachers look toward museums and all they offer for instructional content and material, they are expanding students' thinking beyond the traditional artroom. They are assisting students in broadening their abilities to think and learn, to look within their own communities for points of discussion, and to participate in aesthetics decisions that relate to a multitude of interesting and relevant situations. Calling attention to the museum and its programs is a show of support for them, which sends a powerful message to students about the importance of such institutions. By examining a museum, students also begin to understand the role it can play in their lives. For example, the more they reflect on a museum's work, the more they will understand how culture is preserved and how that affects them. An understanding of museums will also lead students to look to similar settings for future learning and appreciation of art.

Notes

1 Personal interview, December 2, 1997. Ms. Johnston teaches at the Pineview School, Sarasota, Florida.

2 Marilyn G. Stewart, *Thinking Through Aesthetics*. Worcester, MA: Davis Publications, 1997.

3 Petra Mathers, *Victor and Christabel*. New York: Alfred A. Knopf, 1993.

4 Mike Dickinson, *Smudge*. New York: Abbeville, 1987.

5 "Noteworthy." *Museum News*, 77(1), 1998, p. 20.

6 Joy Richardson, *Inside the Museum*. New York: Harry N. Abrams, 1993.

7 "Museums Preparing," *The Journal World*, September 1, 1998, p. 8D.

8 "Washington Museum Receives Picasso Painting." *The Journal World*, June 9, 1998, p. 10D.

9 D. Solomon, "In a Solo Turn, a Tempest Over a Famed Tutu," *The New York Times*, May 31, 1998, section 2, p. 36–37.

10 P. H. Hassrick, ed., *The Georgia O'Keeffe Museum*. Santa Fe: Harry N. Abrams in association with the Georgia O'Keeffe Museum, 1997.

11 B. Forgey, "'Art of the Motorcycle' Speeds Down Guggenheim's Spiral," *Lawrence Journal World*, August 1, 1998; p. 7D.

12 Stephanie Terenzio, ed., *The Collected Writings of Robert Motherwell*. New York: Oxford University Press, 1992, p. 131.

13 P. Koetsch, M. Daniels, T. Goldman, and C. Leahy, "Student Curators: Becoming Lifelong Learners," *Educational Leadership*, 51(5), 1994, pp. 54–57.

14 *The Official Museum Directory*, 1997, p. 221.

15 Carr, *Then and Now: American Portraits of the Past Century from the National Portrait Gallery*. Washington, DC: National Portrait Gallery, Smithsonian Institution. 1987.

16 Carr, 1987.

17 K. Braen and C. Congdon, "An Elementary School Museum Celebrates Community Diversity," *Art Education*, 47(4), 1994, pp. 8–12.

18 Peggy Thomson and Barbara Moore, *The Nine-Ton Cat: Behind the Scenes at an Art Museum*. Boston: Houghton Mifflin, 1997.

19 J. Marshall and L. O'Flahavan, *Collecting Their Thoughts: Using Museums as Resources for Student Writing*. Washington, DC: Smithsonian Institution, 1995.

Working with Museum Educators

*"The museum through its programs, collections, and the manner in which we teach is relevant to
a student's education in that we try to dovetail our efforts with the goals of teachers . . .we work very
hard to make sure that what we're doing for teachers and students is at least coming close to if not
intersecting with the actual goals within the schools."[1]*

—Allison Perkins, Education Director, Amon Carter Museum

Pretend for a moment that you are a traveling art teacher. You are responsible
for three elementary schools and teach an average of seven classes per day. Your
school district has recently issued its curriculum guidelines; they now require the
inclusion of state resources in the classroom. Local administrators are eager to
see the implementation of this mandate. The community appears to have a
number of good artists and artifacts that could be incorporated in meaningful
ways. You are excited about implementing the new guidelines, but it is difficult
to find written information about local artists.

From your art museum field trips, you recall that a
local museum, though small, recently held an exhibi-
tion of watercolors by state artists. You call the edu-
cation department and explain your situation to a
museum educator. She responds by suggesting a
meeting. The museum educator shows you some
slides and describes the work of local artists. You
describe some of your curriculum concerns and
together you discuss ways to integrate such materials
in your teaching. The museum educator offers you a
copy of a newspaper review of the exhibit. When
you ask about other local resources, she directs you
to a historic house that has early photographs of city
architecture. She suggests some possible links to the
art curriculum—perhaps a lesson on architecture or
photography. The museum educator also reminds
you that there are public sculptures located down-
town that you might incorporate into a lesson con-
cerning state history or public art. The city-owned
gardens present an additional opportunity to exam-
ine aesthetic issues. You come away from this single
meeting with a variety of productive ideas for future
instruction.

This is a fictitious scenario. Yet, it is a feasible one
for many art teachers. And such a simple request or
inquiry can lead to a rewarding and long-lasting
museum-school relationship. Of course, situational
factors like distance and time can impact the possibil-
ity of such a relationship. And for some teachers, it
may not be possible. Nevertheless, turning to muse-
um educators for leads on available resources is of
primary importance.

Partners in Planning

Museum education departments develop school ser-
vices to meet the needs of students. Art teachers can
help museum staff members achieve these educa-
tional goals by offering feedback about school pro-

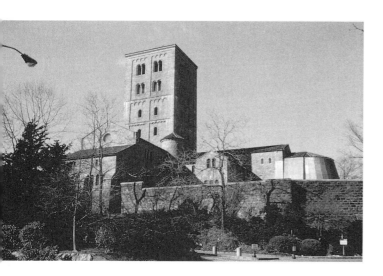

4.1 *Charles Collens,* Cloisters Museum, *1935–38. New
York. Photo: Davis Art Slides.*

grams and resources. They can work with museum educators to plan museum visits, and request that museum educators suggest ways to integrate museum visits into the classroom. Such interaction allows museum educators to better tailor their approaches to specific classroom needs. This dynamic exemplifies the essence of museum-school relationships. These relationships are based on a willingness to exchange ideas and to openly discuss educational issues. In turn, this dialogue can lead to more effective school programs and ultimately contribute to students' lifelong appreciation of art.

How are these relationships beneficial to art teachers? How can teachers approach the museum? And how can art teachers develop a museum connection that will benefit both the art curriculum and the students? These are some of the important topics addressed in this chapter. The chapter also offers some examples of successful school-museum collaborations.

Museum Offerings

By working with museum educators, an art teacher can discover meaningful curricular connections with museum collections. These connections have much promise for helping students identify with both art and the museum in a personal way. Perhaps one of the most important benefits of museum-school relationships is that art teachers and students begin to think about learning in a new way. In a museum gallery, students can study, analyze, and discuss concrete, unique objects. They can explore artifacts from different perspectives, which can lead to multiple ideas concerning people, culture, history, values, and other topics. With such an approach, students can begin to see a museum as an integral and important part of their community—as well as an important place to learn.

Art museums have a long history of working with schools in an effort to provide services to students; such relationships can be traced back to the end of the nineteenth century. Since then, museum offerings and services have evolved, and interaction with schools has increased. Today's museum staff members work diligently to make collections accessible to school populations. There appears to be an emerging pattern of cooperative efforts between museums and schools across the nation.[2]

Educators, administrators, and museum educators share similar goals and are involved in an exchange about student education. Museum educators are eager to make institutional resources available to students, and at the same time, they are keen to help school-age students develop a lifelong appreciation of art. School district goals are often considered and used by museum education departments to improve museum instruction. Ideas such as focusing on critical thinking, finding new ways to help students learn, and developing more concrete instructional activities are part of this development.

In general, museum offerings fall into the following categories: teacher and school services, adult education, and family and youth programs. Museums generally announce their offerings in brochures, posters, local newspapers, museum web sites, and journals such as *ARTnews*. Art teachers might decide to display or disseminate promotional posters and brochures—or even use them to inspire a classroom lesson or project. Students might, for example, complete assignments that ask them to play the role of a researcher or reporter. Teachers also might call attention to adult education and family and youth programs by announcing special exhibits, gallery openings, tours, lectures, performances, films, and programs such as studio workshops and classes.

First Steps Toward Making a Connection

The thought of making a connection with an art museum may seem overwhelming, but it need not be a daunting or confusing venture. At first, one's goals and invested efforts can be modest. Once an initial connection is established, the relationship may grow and develop into one that is long term or more official. The following sections offer some suggestions for initiating a relationship.

Getting to Know Your Museum

Many museum education departments offer credit and noncredit workshops and courses for teachers. This type of instruction can help acquaint teachers with a museum, its collection, and its education staff. Museum workshops and courses typically include lectures about artists, artistic styles, and cultures. Instructional content is often designed to inform teachers about a collection and incorporate that information into classroom instruction. Museums often supply teachers with slides and color reproductions of the works highlighted during instruction. Teacher materials—such as lessons, contextual information about artists, and timelines—may be available. Museum workshops and courses also may offer opportunities to learn new skills for helping students look at and talk about art.

All these benefits can supplement classroom instruction concerning a specific museum's collection and also about art in general. The chance to meet museum educators is another benefit; it may lead to fruitful exchange about classroom needs, adaptations of museum materials, and other relevant topics. Making contact with a museum education department represents an important opportunity to begin exploring the relevance of the museum's services to one's own teaching situation.

Finding Out About Museum Materials

Museum education departments regularly develop educational materials for art and classroom teachers. These resources may include teacher packets, lessons and ideas for classroom instruction, traveling trunks, teacher guides, and other support materials. Education department staff members often solicit the advice of their targeted audience—the teacher—for feedback. They also may request assistance in developing materials. Teacher advisors can be invaluable to museums by furnishing their ideas about how resources can be used in the classroom. In essence, such a partnership can allow teachers to field-test and improve museum materials so that they best meet teachers' needs. By volunteering to work with a museum in this way, teachers also allow the museum to move closer to the classroom.

Another benefit of such a relationship is the possibility of a successful and profitable museum-school relationship. When teachers work with museum educators to devise educational supports, they are familiarizing museum staff members with the realities of the classroom. Such cooperative efforts can help make a potential museum-school relationship both compatible and complementary.

Museum-School Collaborations

A museum-school collaboration is a special partnership in which members from both institutions—museum educators and teachers—work together to form an alliance. Ongoing interaction enables participants to develop programs specifically suited to students' needs, such as activities and materials based on museum experiences that are linked to classroom instruction. One important outcome of such a collaboration is the opportunity for students to experience in-depth learning about art. Ultimately, this can lead to a lifelong appreciation and support of the visual

arts. Indeed, when museums and schools work closely together and communicate on a routine basis, they become partners in education.

Collaborations can take many forms and yield many rewards. They may be short term or long term, formal or informal. A formal collaboration usually establishes a set program for a certain population of students. It entails multiple museum visits often accompanied by in-class presentations. Such a program has specific goals, a title, and a life span that may be determined by funding. The topics and goals of a formal collaboration can vary depending upon a museum's collection and a teacher's needs.

Less formal arrangements are more difficult to categorize. Unlike set programs, their circumstances vary from one situation to another. However, a common thread that links them is the ongoing united effort of museum educators and teachers.

Philadelphia: The Friends Select Curriculum

The Friends Select School established a formal collaboration with the Philadelphia Museum of Art (PMA). The partnership, which originated in 1993, is one of many that the museum has established with local schools and agencies, and it exemplifies the museum education department's philosophy to improve education in the community. The Friends Select School has a curriculum for grades 8–10, "Interdisciplinary Sequence in the Humanities." It requires the use of local resources such as museums. The Philadelphia Museum of Art provides assistance and resources to support the program. They help teachers incorporate the collection as it fits into the curriculum.

To accomplish its goals, the program promotes the use of available resources in the Philadelphia area. All ninth graders visit the PMA three times with teachers to study humanities topics. For example, as part of their study of the Medieval and Renaissance

On Collaborations

"The collaborations are . . . the personal relation-
ships with the team members of the museum. I
have a partner in education. And that's exactly how
they appear to me. . . . And that's really valuable.
That's an incredible resource. And then the fact that
I have this extended classroom of my own, so my
room is not as small as I really feel it is. It's out
there in the community as well. And the kids feel
like they have ownership over the works as well.
[The works] are not just something they go see
every now and then; they're their works of art. . . .
I can't imagine living in a community where we
didn't have that resource."

—Deborah Herbert, elementary art teacher, Venice,
Florida (talking about the Ringling Museum in
Sarasota)

On Collaborations

"True collaborative programs that involve
partnerships blessed at the highest levels of both
educational institutions are beginning to emerge
everywhere. As museum educators respect school
educators as equals, they have become more sensi-
tive to developing programming that applies directly
to what is happening in the classroom. As teachers
watch students who have problems with traditional
learning models come alive in museums, they find
new ways to reach these students."[4]

—Diane Frankel, Director, Institute of Museum
Services

periods, students examine related PMA collections
such as architecture, manuscripts, and armor. The
curriculum also addresses Islamic cultures. Students
have the opportunity to study the designs of Middle
Eastern rugs, tiles, and manuscripts.

In addition to the three class visits, individual
students also attend the museum at least twice to
conduct research on an object in the collection. At
the end of the year, students give parents a tour of
the museum based on research done with the assis-
tance of the Philadelphia Museum Education
Department's staff.

Sarasota: The Ringling Museum of Art
The John and Mable Ringling Museum of Art in
Sarasota, Florida, has undertaken statewide informal
collaborations with classroom and art teachers. The
museum actively seeks the participation of schools in
planning museum services, and it offers summer
institutes to help teachers bring the museum to the
classroom. These institutes were funded by the Getty
Center for Education in the Arts. They helped the
Ringling to build an extensive network of Florida
teachers and administrators. The museum's inclusion-
ary philosophy pervades all that it does for Florida
schools—including its ongoing development of muse-
um events, experiences, and school materials.

One example of the Ringling's offerings is an edu-
cational packet developed by a team of teachers and
museum education staff members. The packet sup-
ported an exhibit, "John Ringling: Dreamer, Builder,
Collector," that highlighted Ringling's vision for
Sarasota and his dream for a museum that would
encompass his collection of art. This resource includes
materials for assisting students in learning about
Ringling, the foundation of his museum, and the col-
lector's influence in the community. An art teacher
who assisted with the packet's development imple-

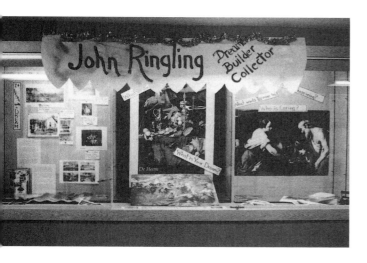

4.2 *Display case designed by Deborah Herbert for the Garden Elementary School in Venice, Florida.*

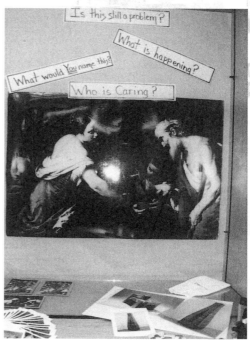

mented its contents both at the museum and in an art classroom. In-class activities explored aesthetic issues and engaged students in criticism activities. An accompanying studio project involved the examination of Italian Renaissance and Baroque architecture—one of Ringling's favorite topics. After studying elements of local structures, students designed their own building. Such packets are developed by the museum continually.

Boston: The Connections Program

The longevity of the Connections program reflects the mutual work of the education staff at the Museum of Fine Arts (MFA) and teachers at the Boston Latin School (BLS). In existence since 1989, the program was made possible through a National Endowment for the Arts grant. BLS received the grant to link students with cultural institutions such as the MFA, the Isabella Stewart Gardner Museum, the theater, and the ballet. A critical feature of the

collaboration is that funding permitted an entire year of joint after-school planning by a team of BLS teachers and MFA education staff members. This planning year forged the collaboration and led to an interdisciplinary program in the arts for eighth grade students.

The Connections program assists both teachers and students in making connections between various subjects and area cultural institutions. Themes such as "Daily Life Around the World," "Images of Power," and "Mythology East and West" are part of the program.

For teachers, the MFA is an extension of the classroom, and the MFA collection is central to studying the curriculum—whether poetry or history. For example, students may study a myth and then visit the museum to discover how artists have used that myth as subject matter. In the process, students are also asked to compare mythic heroes to current superheroes. The program also involves students in viewing and writing activities. Although the funding period has ended, collaborative efforts continue between the MFA and the BLS. For example, the MFA hosts an open house for the Boston Latin School each fall.

Fort Worth: Partners Through Art

Partners Through Art is a collaboration between the Amon Carter Museum and teachers of the Fort Worth Independent School District, Texas. It entails multiple museum visits each year for twelve schools, elementary through high school. The program was originally inspired by a local teacher who wished to provide her students with greater exposure to the museum. Although the program began in 1991 with modest goals, it has grown exponentially through the support of a Metropolitan Life grant.

The program's content, developed during regular meetings between teachers and museum educators, includes activities and materials that mesh with the goals of the Fort Worth school district. Teacher input also resulted in gallery teaching that encourages critical thinking skills and lifelong learning in art. The program's success is attributed to extensive teacher and docent training, routine evaluation of the program, and the involvement and support of administrators. The museum also facilitates communication between docents and teachers, bringing to light their individual needs.

Boston: School Partnerships Program

The Isabella Stewart Gardner Museum is meeting the needs of neighboring schools through its School Partnerships Program. Students in six schools within walking distance of the institution participate. This distinctive multi-visit program incorporates the work of artists-in-residence—whether dancers, jazz musicians, writers, or visual artists—into the curriculum. The artist-in-residence, museum educator, and classroom teacher all work toward establishing meaningful links between the classroom and the museum.

The program also involves students in various artistic experiences through hands-on activities. Previsit instruction, which is planned by both the museum educator and the classroom teacher, usually features historical material about the museum and its founder. The museum lesson is given by an artist with a follow-up in the classroom. Participating teachers must attend three meetings during the program. Teachers and students (parents too) have free access to the museum. Teachers can visit the museum with students as often as they wish.

A storyteller who facilitated student learning about the collection is one example of the program in action. The storyteller read *The Gentleman and*

the Kitchen Maid to elementary students in one gallery that houses many Dutch works. The artist took advantage of the book's story, which happens to highlight Dutch paintings with characters who speak to each other, prompting students to observe and discuss the museum's collection. The storyteller later visited school classrooms, reading a second book to further reinforce the connection between students and the collection at the museum. The four-year School Partnerships Program started in 1997 with the help of a Pew Charitable Trust grant. Grant funding enables students and parents to receive free access to the museum, and teachers can obtain museum resources and training through teacher residencies and institutes.

Baltimore: Ceramic Museum School Program
The National Museum of Ceramic Art and Glass initiated a program in 1995 with city and county middle schools. The program provides potter's supplies and equipment to classrooms, and students create their own finished clay pieces. Initially only two schools participated in the project, but with time it has grown to include twenty-nine and is still growing. Teachers are surprised and amazed by the changes observed in students who work with such hands-on projects. The partnership, created by the acting director of the museum (a former teacher), has brought attention to the way students can be affected by the arts. The focus is on making three-dimensional work—a way of working that, because of classroom logistics, often receives less attention in the regular art curriculum.[5] This program emphasizes an interdisciplinary approach, using ceramic art to enhance core curriculum subjects. With both formal and informal elements, program components include in-school and after-school work, teacher trainings, and student workshops and exhibitions.

Conditions for Successful Museum-School Partnerships

- Commitment from school and museum professionals.
- Involvement of school and museum professionals early in the program.
- An understanding of school curricular needs.
- Goals common to both museum and school staff.
- Sensitivity and responsiveness to the organizational structures of the museum and the school.
- Realistic goals resulting from planning and evaluation.
- Sufficient resources.
- Clearly defined roles, responsibilities, and expectations driven by planning and evaluation.
- Ongoing communication.
- Concrete benefits for teachers.
- Flexible planning and the freedom to experiment.
- Involvement of students' parents and the community as a whole.[6]

Guidelines
You now have an idea of some kinds of relationships that are possible between a school and a museum. As you begin to consider building your own relationship with museum educators, you will need to take into account some general issues. One can think of these as guidelines for museum-school relationships. These ideas are based on factors found in successful relationships between museum educators and teachers in various parts of the country.

4.3 *Students visiting the John and Mable Ringling Museum of Art. Teacher: John Delp.*

Guidelines for Museum-School Relationships

1. Seek opportunities to develop relationships with individual members of the education staff. This is a central factor in many successful museum-school relationships, and is especially true for programs with a long history.

2. Understand that planning time is critical. Be prepared to invest time in building the relationship.

3. Become acquainted with the collection through museum workshops, written materials such as catalogs, and through conversations with museum educators. The more familiar you are with a collection, the better able you will be to develop curricular connections.

4. Identify curriculum structures that promote the relationship. That is, assess what aspect of the art curriculum meshes with a collection. If these connections are identified, then real needs will be met. Let parents know how the museum relates to the curriculum and how this benefits students. Use innovative ways to highlight students' learning concerning museum collections.

5. Solicit the support of administrators. Evidence suggests that long-term museum-school relationships have the commitment of administrators behind them. Demonstrate how the museum is relevant to all subjects—including math, science, and social studies. Help administrators understand what museum connections can do for students. It also may be helpful to engage the support of other subject area teachers in this effort.

6. Develop networks with other people who are interested in establishing connections between the museum and the school. Individuals who are inspired by the idea—whether inside the museum or outside arts agencies or artists—can help to make things happen.

Conclusions

There are numerous approaches for teaching about the art museum. Establishing relationships with museum professionals can strengthen teachers' menu of curricular ideas and activities. Although teachers and museum educators work in different milieus, they share very similar goals. By working together, they develop instruction that is closely allied with the art curriculum and plan for ongoing integration of museum collections in the artroom. Together, they can forge important educational partnerships.[7]

4.4 Frank Furness, George Hewitt, Pennsylvania Academy of Fine Arts *(façade, entrance), 1871–76. Philadelphia. Photo: Davis Art Slides.*

Notes

1 Interview, November 18, 1997. Allison Perkins is now at the Baltimore Museum of Art.

2 H. C. Hirzy, *True Needs True Partners: Museums and Schools Transforming Education*. Washington, DC: Institute of Museum Services, 1996.

3 Burchenal was at the Museum of Fine Arts, at the time of the interview. She is now at the Isabella Stewart Gardner Museum.

4 Diane Frankel, "True Needs True Partners." From H. C. Hirzy (ed.), *True Needs True Partners: Museums and Schools Transforming Education* (pp. 9–14). Washington, DC: Institute of Museum Services, 1996.

5 S. Pekkanen, "Shaping Up," *The Lawrence Journal World*, May 28, 1998, p. 8D.

6 Hirzy, p. 50.

7 Much of the material in this chapter was obtained as part of a research study titled "Art Museums and Schools: Partners in Education" funded in part by the National Art Education Foundation, the Joyce and Elizabeth Hall Center for the Humanities, and the General Research Funds, The University of Kansas, Lawrence, Kansas. The author interviewed both art and classroom teachers and museum educators at seven museum sites located in various regions of the country to examine museum-school relationships and collaborations.

The Internet as a Museum
Education Resource

A century ago, teachers of art could hardly have imagined the resources available today. The Internet permits access, twenty-four hours a day, seven days a week, to a multitude of electronic data including the collections of art museums around the world, as well as numerous other cultural institutions. Once on-line, we enjoy unprecedented opportunity to search for information about artists and art from a variety of time periods and cultures. This chapter will explore what is available to art teachers and students on the World Wide Web, how to evaluate this material, and how one might incorporate it into classroom instruction.

Some Important Terms

Browser A program that allows retrieval of information on the World Wide Web including text, visuals, and files. Examples of browsers are Microsoft Internet Explorer, Netscape Navigator, Lynx, and Mosaic.

Directory A directory is a web site that allows users to search for categorical information. It is particularly useful when one is looking for general material on a topic. Arthlinks (http://witcombe.sbc.edu/ARTHLinks.html) is a directory for investigating art-history topics and resources. There are an increasing number of sites with search engines that permit specific searches.

HTML HyperText Markup Language is based on a coding system comprised of embedded tags that format, link, and describe information on the Web.

Meta-Search Engines These allow the user to simultaneously search several databases. Meta-search engines are especially useful for obtaining a broad overview of a subject.

Search Engine This is a web site with a database that permits the investigation of specific topics. A search engine is very useful when the key term, phrase, or name is known; it will often yield a lengthy list of possible choices to investigate. The user types in a keyword(s) or term(s), and the search engine provides a list of matches. World Wide Arts Resources (http://wwar.com) is an excellent tool that offers information about art museums. Other examples are Google, Lycos, LookSmart, and Infoseek.

URL The Uniform Resource Locator represents the location or address of a file on the Internet. URLs typically have the following format: http://www.whitehouse.gov.

Web page An electronic document, formatted in HTML (HyperText Markup Language), that represents the basic unit of the Web. It typically integrates text and images. Users scroll up and down to obtain information. A web page may have links that permit quick navigation to other pages.

Web site A collection of unified and linked documents (or web pages) in HTML format available on the World Wide Web. Some web sites consist of only one web page yet contain much information.

World Wide Web This is one of the fastest growing parts of the Internet. The Web is comprised of connected computers that enable the rapid transfer and exchange of information (text, images, graphics, audio, and video formats).

5.1 The Detroit Institute of Arts can be found on the World Wide Web at www.dia.org. Paul Philippe Cret, Clarence Clark Zantzinger, Charles Louis Borie, Jr., Milton Bennett Medary, The Detroit Institute of Arts, 1927. Detroit. Photo: Davis Art Slides.

Museum Web Sites: Background Information

The World Wide Web, commonly referred to as "the Web," is a system of distributed information that enables computers to understand and retrieve text, files, visuals, and sounds. The Web allows the presentation of high-quality images on the Internet alongside valuable text-based resources. Museum professionals have taken advantage of this sophisticated technology and designed impressive sites to showcase their collections and special exhibits, thereby exposing a great number of people of all ages to their institutions.

Museum web sites represent an important resource for art education instruction. Teachers can employ electronic information to plan field trip activities, including preparatory instruction and post-museum visit lessons. Also, you can obtain invaluable materials concerning collections as well as curriculum tools. Related benefits are the text and catalog references provided by institutions. These give important historical facts about works of art and artists. Yet another reason for exploring museum web sites is the availability of links to other good sites. The required tools for exploring these resources are a computer, a browser, and Internet access. For a note about student safety on the Internet, see page 117 of the Appendix.

Museum Web Sites: An Overview

The Internet's rapid transmission of data on a widespread basis is important to museum professionals. Home pages disseminate up-to-date information about visiting hours, membership, special programming, lectures, and workshops. They also enable visitors to access museum shops offering on-line purchases such as catalogs, books, and other items. The National Portrait Gallery in London

Did You Know?

Digital images permit the examination of artworks from various institutions all over the world. These visuals are composed of a multitude of pixels that are similar to grains in a photograph. A digital image will appear differently on a monitor than it does in print form. This is due to the way color is created.

On a computer monitor, color results from emitted primary light colors (red, green, and blue). Printed images have color because of the reflection of light on the ink in secondary colors (cyan, magenta, black, and yellow). The technology used to create a digital image is sophisticated, requiring planning and the examination of important questions.

Discussion Point

Consider the role of technology in representing museum collections. Among museum professionals, much time has been spent discussing and planning how images might be presented on the Internet. Some wonder whether digital representations of originals will substitute for actual museum visits. Others are rightfully concerned that museums will lose the ability to ensure the responsible use of their images. Lead students in a discussion of the following questions:

- Technology permits users to download or copy images without an institution's knowledge or permission. Rental fees and licensing agreements allow museums to control the reproduction of images on manufactured products (such as coffee mugs), and to defray the costs of caring for collections. Computer technology could compromise these possibilities. Is this fair to museums? Should laws be written to control these kinds of activities and outcomes?

- Computers now permit the high resolution of images found at museum web sites. Some sites even permit close observation of brushstrokes and textures. Will museums lose their audience to sophisticated technology? Is visiting a museum web site equal to seeing actual art? Why or why not?

- Compare downloaded images with printed reproductions. If originals are accessible, students could make additional comparisons. Which is closer to the actual artwork—an electronic image or a commercially available reproduction? Why?

(http://www.npg.org.uk), for example, publishes extensive printed materials ranging from catalogs, illustrated books, and instructional tools to posters and postcards. Its web site lists new, future, and older titles across various subjects, including art, history, photography, biography, and fine art.

Museum web sites also highlight special exhibits. They may exhibit selected works of art, offer schedules, and supply background information, related references, and other useful facts. On-line coverage of special exhibits is determined by a number of factors—the host institution, contributors, subsidiary organizations, and the artists involved. Once a special exhibit closes, electronic data may be archived or it may disappear from the site.

The Solomon R. Guggenheim Museum (http://www.guggenheim.org) retains previous exhibition resources. For example, "Claes Oldenburg: An Anthology" (1995–96) includes a brief description of the exhibit, images of the artist's works, and contextual information. Another example is "Africa: The Art of a Continent" (1996). Introductory text and artifacts from different parts of Africa are accessible, including a map that serves to identify the regional origins of artifacts.

Museum web sites often offer extensive information concerning education departments. Art educators can learn much about tours, lectures, workshops, and courses, as well as obtain teacher materials. This type of data is useful when planning field trips or identifying instructional opportunities. The Amon Carter Museum (http://www.cartermuseum.org), for example, gives an overview of the museum's educational offerings that spans school visits, teacher resources, and teacher training. Teachers can make on-line arrangements to visit the museum.

Museum educational services and resources can also be useful to educators who are geographically

distant from the institution. The Nelson-Atkins Museum of Art (http://www.nelson-atkins.org) provides teacher packets for a nominal fee. Consisting of slides, bibliographies, sample activities, and other useful material, titles include "Native American Art," "African Art," "Chinese Art," "American Painting," "Masks," and "Highlights of the Permanent Collection." Like those produced by many museums, such offerings can help teachers expand their art instruction or amplify aspects of their art curriculum.

The Scope of Offerings

The scope and range of on-line information varies among institutions. There are basically two approaches that museums use to feature their collections.[1] They may present works as part of a department or collection (paintings, prints, sculpture, etc.) and spotlight several works. Le Musée du Louvre (http://www.louvre.fr), for example, has one of the largest art collections in the world. Its paintings alone number about 6000. The Louvre's web site presents a handful of images representing major works from various periods of art history. Descriptions of these images and explanations of their significance are incorporated.

The second approach of presenting a collection on the Web is to highlight all or most of the pieces in the custody of an institution. The San Francisco Museums of Fine Arts (http://www.thinker.org), for example, offers the ImageBase with more than 75,000 of the collection's objects accessible on the Internet. An on-line visitor can search for artists' works and use a zoom feature to view high-resolution images.

Regardless of the approach, an important goal when exploring a museum web site is to become familiar with the networking potential of each address. In other words, users can fully benefit from

Discussion Point

Mount Athos, located on a peninsula in northern Greece, is known as the Holy Mountain. The sacred area has about twenty Eastern Orthodox monasteries, all of which keep artifacts and treasures. Considered as a whole, this is one of the largest collections of Early Christian works in the world.[2] The treasures include icons, manuscript codices, mural paintings, portable icons, silver and gold vessels, and vestments. With the exception of one exhibit, no artifacts have ever left the Holy Mountain.

For most people, a virtual visit is the only means available to view many of these artifacts. The rugged, mountainous terrain where the monasteries are located isolates the site from the rest of Greece. Yet, geography is not the only challenge to prospective visitors. The monasteries are governed by strict religious mandates to preserve and protect them. Only men with a special permit are allowed to enter. A total of 100 Orthodox males are allowed on the peninsula per day; only ten non-Orthodox males can enter per day.

What do you think are the advantages and disadvantages of having such viewing restrictions? Visit these web sites to learn more about Mount Athos. http://poseidon.csd.auth.gr/athos/index.html and http://134.181.128.3/~rallison/friends/index.html

virtual museum visits when they move from information about one department to that of another. For example, you may first learn about the history of an artwork in the curatorial department. From there, you may move to the education department to discover related curricular materials. Exploring such links and interacting with various departments are important activities for successfully tapping the available resources. The search process is relatively easy and takes little time to learn.

Locating Art Museums on the Web

Becoming acquainted with museum web sites entails some exploration time. It requires the use of Uniform Resource Locators (URLs), or Web addresses, to locate a file on the Internet. Users can employ a directory or a search engine to secure URLs. World Wide Arts Resources (http://wwar.com) is an excellent tool for obtaining art museum Web addresses. It is easy to navigate, and it gives numerous options for visiting art museums worldwide. Searches for museums within categorical listings—such as media (painting, wood, metal, etc.) and type (design, craft, and sculpture parks, etc.)—are also possible. Along with art museum information, World Wide Arts Resources offers inquiry into topics such as art education, art history, antiques, and other subjects that can support art museum education in the classroom.

Another valuable web site is the Art Museum Network (http://www.amn.org). It has numerous links to institutions. A user can search for specific collections and obtain up-to-date exhibition calendars. One can also look for displays of certain types of art—for example, glassware, watercolor, or sculpture. To visit listed institutions, the user need only select the desired links.

There are two important issues to remember when exploring the Web, especially museum web

sites. First, the Web is constantly changing and information available on a particular day may disappear the next. Second, downloading images requires paying close attention to reproductive copyright statements. Museums provide this information, and the statements must be carefully read prior to downloading.

Examples of Home Pages

One vehicle to help educate new audiences is a museum's home page. Visiting home pages is a good way to become familiar with museums on the Internet. From this starting point, users can quickly navigate through curatorial departments, view works of art, and download images. While such a virtual visit is not the same as an actual museum experience, users can learn much about artifacts in institutions around the world. You may wish to have students complete a simple worksheet about the museum, such as the one on page 118 of the Appendix. The worksheet can then be used as a tool for students to compare museum sites without actually being on-line. The following is a starter list of Web addresses. These sites are valid as of Spring 2001.

The Detroit Institute of Arts
http://www.dia.org

The Detroit Institute of Arts has fast links that allow users to quickly jump from one department to another. Visitors can search a database of images from the permanent collection and also create a gallery of selected works. Also useful to art educators are field-tested lessons on various topics across classroom subjects (art, language arts, math, science, and social studies). Each lesson has goals and objectives, images showing examples, teacher comments, and assessment procedures.

Try This

Develop Virtual Field Trips

Have students develop a virtual museum field trip for their classmates. Provide pairs of students with a list of possible art museum web sites to visit. Students investigate the location, collection, and public programs available. They also download several images to represent the collection.

To develop a "field trip," students may put together a ten- or fifteen-minute computer presentation that identifies the geographic location of the museum and facts about the collection. By doing so, they will learn Internet search strategies and become familiar with directories and art-related Web resources. You may wish to highlight all visited museums by identifying them on a large map.

Variation: Have students develop virtual field trips to institutions with specific collections, such as Roman artifacts or modern sculpture. Or, they might look for certain types of art such as glassware or textiles. Students may investigate the museum's history and attempt to discover why the institution has collected these pieces. The field trip might offer contextual information as well as background material about the institution.

The Heard Museum

http://www.heard.org

This is an easy-to-navigate site, with quick links and valuable educational resources about Native American artifacts. The museum is dedicated to the collection and preservation of Native art with an emphasis on traditional cultural pieces of the Southwest as well as changing contemporary Native culture. Educational materials are plentiful, including classroom guides, slides, art-historical information, and more.

Le Musée du Louvre

http://www.louvre.fr

The Louvre provides a well-designed, organized overview of its immense collection, including examples of major works accompanied by background information. Images can be quickly enlarged and downloaded. The site also offers information about the origins and interesting history of this institution.

The Metropolitan Museum of Art

http://www.metmuseum.org

This comprehensive site permits users to navigate easily from one department to another. Impressive on-line educational resources include a timeline with sample artworks from the collection, a "virtual gallery walk" that corresponds to an on-site special exhibit, and teachers' packets. The Met also offers a look at previous and current special exhibits, examples of images, and catalog information that can be useful for art education instruction.

Montreal Museum of Fine Arts

http://www.mmfa.qc.ca

The Montreal Museum of Fine Arts presents an engaging and sophisticated site. The education department offers contextual information concern-

ing special exhibits, teacher materials with pre- and post-museum visit ideas, and follow-up activities. These resources are applicable to art education instruction even without an actual museum visit. The site also offers educators and students integrated resources and links to learn more about the collection. For example, users can visit other web sites that highlight artists in the collection.

The National Gallery of Art

http://www.nga.gov

This exciting and comprehensive site enables visitors to access extensive, detailed facts about the collection. An immense database of more than 10,000 objects and a custom search engine enable users to find artists' works by period, medium, and date. Contextual information can be readily downloaded and incorporated into classroom instruction. The site also offers virtual tours that correspond to tours given in the galleries. Art educators will find an extensive menu of curricular-based tools, including teacher guides, programs, lessons, and brochures.

The National Museum of Women in the Arts

http://www.nmwa.org

The museum home page is rich with information. The NMWA recognizes the achievements of women artists and features works from the Renaissance to the late twentieth century on its site. Introductory material, artworks, and extensive bibliographic information and artists' profiles accompany each period. Images can be quickly enlarged for ease of viewing. The site is invaluable for student research.

The National Portrait Gallery

http://www.npg.org.uk

London's National Portrait Gallery has a comprehensive, interesting site. It offers surprising informa-

tion on a number of topics related to current and past exhibits. Departments can be quickly and easily accessed. Visitors are offered an extensive and well-organized catalog list accompanied by concise descriptions and purchasing information. A "Picture Library" feature provides various services, including the opportunity to obtain reproductions. Examples of educational practice might prove useful in planning comparable instruction.

Seattle Art Museum
http://www.seattleartmuseum.org

The Seattle Art Museum provides easy, interactive search features. Users can learn about the collection through "SAM Art Start" on-line tours, which are accompanied by background information. Teachers can access instructional units that correspond to on-line tours; these units have goals, objectives, and strategies. "Art Essays" provides contextual matter about the collection with the opportunity to e-mail questions to research associates. A "Hot Seat Dialogue" highlights the opinions of different staff members on a number of topics.

The San Francisco Museums of Fine Arts
http://www.thinker.org

This combined site for the de Young Museum and the Legion of Honor provides a good overview of current exhibits, and includes historical information about the origins of the collection. The site offers a search engine called the ImageBase, which permits access to more than 75,000 images representing approximately 12,000 artists.

resources

NATIONAL GALLERY OF ART

WHAT'S NEW
HELP
FEEDBACK
SEARCH
SITEMAP

SHAW MEMORIAL
POLLOCK

planning a visit
the collection
exhibitions
online tours
education
programs & events
resources
gallery shop
ngakids

ART RESEARCH LIBRARY
National art research center serving the Gallery's staff, visiting scholars, and qualified researchers.

CENTER FOR ADVANCED STUDY IN THE VISUAL ARTS
Research institute promoting study of the history, theory, and criticism of art, architecture, and urbanism from prehistoric times to the present.

CURATORIAL RECORDS
Files on the National Gallery of Art's paintings, sculpture, and decorative arts holdings.

EDUCATION RESOURCES
Resources for educators, students, and parents, including information on free loan programs, online programs, teacher workshops, teacher institute, school tours, and lectures.

EMPLOYMENT OPPORTUNITIES
Search a complete listing of job vacancies at the National Gallery.

GALLERY ARCHIVES
The Gallery Archives preserves and makes available historical records of the National Gallery of Art and related historical materials.

NATIONAL LENDING SERVICE
Oversees programs that make the National Gallery of Art's collections accessible to museums throughout the United States.

NEWS RELEASES
Read the latest from the Gallery's press office.

PHOTOGRAPHIC ARCHIVES
Study and research collection of reproductive images documenting European and American art and architecture.

PRINT STUDY ROOMS
Works on paper not on display may be viewed and studied by appointment in the Gallery's Print Study Rooms.

SLIDE LIBRARY
Color slide collection of more than 40,000 images of works of art owned by the Gallery.

VISUAL SERVICES
Provides black and white photographs, color transparencies, and 35mm slides of works of art in the Gallery's collections for publication and nonpublished purposes.

WORLD WAR II RESOURCES
Research resources relating to World War II are available at the Gallery and on this Web site.

planning a visit | the collection | exhibitions | online tours | education | programs & events
resources | gallery shop | NGAkids | search | help | feedback | site map | what's new | home

Copyright ©2001 National Gallery of Art, Washington D.C.

5.2 One of the many web pages at the National Gallery of Art web site is their listing of extensive resources, found at http://www.nga.gov/resources/resource.htm. Courtesy of the National Gallery of Art, Washington, DC. Photos by Dennis Brack/Black Star.

Create a Virtual Museum

Discuss the physical organization of a nearby art museum such as the galleries, the way art is displayed, the café, the museum shop, as well as the exterior dimensions of the building. If possible, visit the museum and have students notice where different types of works are on view—for example, ancient art, eighteenth-century works, and contemporary art. They could take note of the way three-dimensional pieces are displayed. Students might also complete a worksheet that requires a floor plan, sketches of gallery walls showing the organization of works, and examples of labels.

Back in the classroom, students plan a web site for their own art museum based on the collected information. They can develop graphics and images for their museum, select artworks created by students for the exhibits, and identify an organizational approach. Use the site to evaluate student learning.[3]

Using Web Resources in Classroom Instruction

Museum Web resources can offer teachers invaluable assistance in planning lessons and units. They can also become an integral part of classroom instruction. Since downloading museum images is easy, teachers can create displays of art from all parts of the world, thus exposing learners on a school-wide basis to a vast array of cultural artifacts and institutions.

Student Use of the Web

Art students might use the Web for a variety of instructional purposes. They may "visit" a variety of museums and study numerous artists' works. Students can do research on the Web, gaining information for oral and written reports. They can also use its resources to help them compile bibliographies, which may incorporate links to relevant web sites.

Computer-based instruction can entail having students create their own web pages. (Since Web documents require the use of HTML tags, a text editor can be employed to automatically insert these elements.) Student-created web pages can complement curricular activities and highlight what is being done in the artroom. Some elements that should be incorporated into such documents are a table of contents, ways to navigate the text, images, or graphics, a consistent organization and layout, and appropriate links.[4] Art teachers can use such student-created web pages as part of their overall evaluation of computer-related classroom instruction.

Students might work together to create a classroom web site that includes information about what they are studying, with links to pages pertaining to certain artists, time periods, and art forms. Students can learn effective search strategies from one another as well as computer skills. As always, educators must be careful to ensure that presentations using the Web meet the standards of instruction.

While the inclusion of computer-based instruction is appealing, art teachers must carefully consider student needs and their own curriculum goals before launching such instruction. Another consideration is the availability of computer equipment; organizing students into pairs or small teams can help to stretch classroom resources.

A Sampling of Web Resources

Prior to the inclusion of the computer in actual instruction, it is important for art teachers to search for appropriate museum web sites. While art museums on the Internet offer useful information, the breadth and depth of subjects and topics vary. A database of museum web sites, as discussed below, can enhance and expedite instruction. The sites listed in this section offer directories or search features for accessing museum and art resources. These addresses can help to secure material on specialized collections, art-history topics, and other types of subjects.

It is important to remember that the Web is constantly evolving. The scope of databases, range of available tools, and other features will be modified over time. Furthermore, it is imperative that users understand that not all web sites are equal. Electronic material is not standardized, so you must scrutinize any content obtained. These addresses have been checked for their pertinence; they are valid as of Spring 2001. However, it is ultimately up to the reader to judge the accuracy and validity of on-line data.

Arthlinks

http://witcombe.sbc.edu/ARTHLinks.html

This site contains a directory of art history topics and resources. In addition, the site has links to museums and galleries.

Try This

Search for Museums Around the World

An important idea to convey in art education instruction is that art exists all over the world. The computer can be used to assist students in becoming aware of international museums. Give students a list of countries, including both Western and non-Western cultures studied in class. Provide directories and search engines to find Web addresses. Student objectives might include:

- select one country and search for the art museums in this location.

- select one institution based on its size and type. (Define the required characteristics for students, for example, the largest in the country.)

- identify one artist whose works are part of the collection and describe a work, including title and visual characteristics.

- download one image as an example of an artist's work (for use in their report).

- report your findings to the class.

Extension

This lesson could be done in cooperation with a social studies teacher. Countries studied in social studies could become part of the list given to art-class learners. Students could consider a museum's history and the role the institution has in relationship to the culture (for example, how art is valued).

Another way to extend the lesson is to have students work in teams and compare and contrast their institutions, focusing on the art and culture of the countries.

Evaluating Web Site Material

Books and journals clearly identify author and publisher; on-line materials, however, are more difficult to assess. When investigating Web resources, it is important to be critical and judicious. Art museum web sites provide reliable and credible information, since the institutions employ art historians to research and write their material. This reassurance does not apply to other web sites. Art educators must help teach students the critical skills needed to become discerning Internet users. The following list of questions might be considered.[5]

- What is the author's affiliation, experience, and background? Is the site maintained by a university or other reputable organization?

- Are images accompanied by identifying facts such as title, artist, and location?

- Compare information against trusted printed matter. Does printed information verify or contradict the Web source?

- Are references or a bibliography given?

- Is the material useful, current, and objective?

- Is the document presented in an organized and consistent fashion?

- What is the purpose of the web site? Does it advertise? Does the site inspire confidence in the presented facts?

- Is this a stable web site? Does it change frequently? What are the chances it will be available in the future?

ArtNetWeb
http://artnetWeb.com

An information-packed site, ArtNetWeb features an extensive index of educational links. Examples include museums, galleries, artists' web sites, libraries, special projects, and distance learning opportunities. This site is useful for searching information on artists, images, galleries, and a host of other art-related subjects.

ARTSEDGE
http://artsedge.kennedy-center.org

A cooperative agreement between the Kennedy Center and the National Endowment for the Arts made ARTSEDGE possible. Its mission is to furnish artists, teachers, and students with new ideas and information for promoting the arts in education. This site presents an array of instructional resources that dovetail with national education goals. It also makes available numerous instructional materials, which are indexed for easy access.

Artsource
http://www.ilpi.com/artsource/general.html

This site offers access to art museums, archives, libraries, indexes, and other useful addresses. Links quickly lead to a variety of interesting places, including the National Gallery, London; the Museum of Fine Arts, Houston; and the National Museum of Women in the Arts, to name a few.

Voice of the Shuttle
http://vos.ucsb.edu

This resource allows extensive searches about art and art history. It has both a directory and a search engine for humanities research.

The Art History Network
http://www.arthistory.net/index.html

Offering a directory of art-historical periods, artists, and civilizations, this site is especially useful for searching information about artists.

Harcourt Brace College Publisher's Art History on the Web
http://www.harcourtcollege.com/arts/gardner

Developed for use with *Gardner's Art Through the Ages*, this site provides useful links to good Web addresses. It is an excellent source of images and contextual information.

The New York Public Library
http://digital.nypl.org

The library offers a fascinating collection of prints and photographs on-line. The Samuel Putnam Avery Collection, for example, has prints by artists such as Manet, Goya, and Whistler. Simply browsing through available resources can yield useful results.

WebMuseum, Paris
http://sunsite.unc.edu/wm

This site has exhibits of works from the Gothic era up to the twenty-first century. A visitor can search for information by artist, theme, period, and type of art. Contextual content and links lead to additional material. A glossary of painting styles is also available.

Developing a Database of Museum Web Sites
Developing a list of relevant museum web sites can provide you with a quick reference of curriculum-based tools. The table on page 118 of the Appendix can be used to identify and record resources. Institutions refresh their web sites on a regular basis,

Try This

Search for Artists' Works

One benefit of using the computer for art education is to help students understand that one artist's works may be located in museums throughout the world. As students learn about different artists, have them search the Web for institutions that have examples of works by particular artists. They can develop a list of artists over a period of time. In addition, students might identify the geographic location of museums on a class map or atlas. Each team reports on collections representing the chosen artists, delivering this information to the class.

Discussion Point

Some think computers are beneficial to society because they democratize art. That is, computers make art available to everyone. Have students think about and decide upon the validity of this statement. Another point of view is that computers make visiting a museum easier. An individual can visit a Web address and learn about the art on view in a museum. Can computers facilitate actual museum experiences? Why or why not?

so it is important to keep an up-to-date record of what is available.[6] Consider asking students to help verify current sites.

Supplementing Museum Web Site Information
The scope of available Web information concerning collections fluctuates for a variety of practical and financial reasons. Therefore, it is imperative for art teachers to employ a number of information formats in addition to electronic materials to assist students in researching artists and works of art. Printed materials such as exhibition catalogs, books on specific museums, and art-history texts often have the most comprehensive material. Many book publishers and distributors offer these materials for sale on-line.

Another important source for supplementing Internet information is the CD-ROM or DVD-ROM. These formats can hold a vast amount of material with images, text, and interactivity. Museums are producing multimedia disks to highlight collections, artists, and their histories. The following is a good example.

Le Louvre: Collections and Palace[7] This CD-ROM gives an overview of seven departments with examples of up to 200 works. In-depth historical information about artifacts, artists, and collectors is given with background about the building, its evolution, construction, and architects. Screens have numerous options for learning about artifacts. Users can view objects in the galleries or in an enlarged format. Various screens also allow users to obtain biographical and historical information, and to compare artifacts across genres, schools, themes, and movements. An album function permits the selection of works and written text, and a user can send images and written material via e-mail.

Sample Web-Related Lessons
The Web can enrich and expand your curriculum. An important first step to incorporating digitized information is to explore what is available. A useful and practical approach is to first consider a specific topic that fits into the class schedule; then, evaluate the usefulness of pertinent Web sites. Although the Internet offers much, Web addresses may or may not have sufficient high-quality text or images to warrant their use. Another important issue is to identify how the sites will contribute to student learning. Exploring the Web might be fun for students; however, it is critical to predetermine what the experience will contribute toward students' overall knowledge of the topic.

The lessons that follow represent two examples of studio instruction that require research on the Web. Also included are student objectives and a rubric for assessment.

The Cityscapes of Wayne Thiebaud
This multiple-part lesson for fourth or fifth graders is a studio project that incorporates museum Web resources. The lesson examines cityscapes with a focus on Wayne Thiebaud's work. Begin the first session by having small groups of students briefly discuss cityscapes. Two questions could guide the discussion: "What do you know about cityscapes?" and "What artists have created cityscapes?" Individual groups provide answers, which are then recorded on the chalkboard. You also might give students a brief overview of the cityscape as an art subject.

Next, show reproductions of Wayne Thiebaud's works—especially those that feature the city of San Francisco. Students should identify the stylistic qualities of the artist's work. You also might show photos of San Francisco to highlight how Thiebaud captures important attributes of the city.

Invite small groups of students to search the ImageBase of the San Francisco Museums of Fine Arts (www.thinker.org) for other examples of Thiebaud's cityscapes. Explain how to use the search engine and give students a worksheet to complete. Worksheets can guide students' work and the organization of their information. They also might pose specific questions, such as: "How many works by Thiebaud are in the museums' permanent collection?" "How much time does the artist devote to his art?" and "Why might the institution have so many of the artist's pieces?" A Thiebaud search alone will yield more than 300 works, many of them cityscapes. Students might download a cityscape and compare it to a classroom reproduction.

On another day, students should choose a city to characterize by concentrating on such features as the skyline and architecture. Provide photographs of various large cities for students to examine. Students then develop some preliminary sketches for a cityscape painting and devote the next few classes to completing the project.

Hokusai and Ukiyo-e Prints

This high school studio project uses computer resources to explore Japanese prints. Begin by providing historical information about Japanese prints and presenting an overview of printmaking processes. Then, delve into the work of the well-known Japanese artist Hokusai and his woodcut printmaking methods. Offer examples of student work, and demonstrate making a woodcut print. Require students to research additional historical information on the Web. Students also may use the Web for inspiration as they plan their own prints.

To ensure that computer searches are productive, provide students with addresses of several directories with which to initiate their search, as well as work-

Discussion Point

Virtual vs. Actual Museum Visits

Explain to students that as a young artist Henri Matisse spent a great deal of time copying master paintings at the Louvre. Between 1892 and 1896, he copied works by artists including Watteau, Fragonard, Boucher, Poussin, Chardin, Ruisdael, and Raphael. Creating copies of masterpieces provided the artist with additional income; Matisse's father gave him only a small allowance with which to live. The French government purchased copies of master paintings to decorate government buildings. Copying paintings was also a form of study for Matisse. The act of copying gave him a chance to observe the interrelationships of shapes and color, and to understand the nuances of composition. This practice also may have inspired Matisse to apply high standards to his own work.[8] Discuss the following:

- Is it possible for a contemporary artist to study images on a computer in the way Matisse studied art in a museum? Why or why not? What might an artist learn from studying digital images? Compare a print of a downloaded image to that observed on a computer screen. Discuss the differences and similarities.

- What might art students during Matisse's time have thought about electronic images of art?

sheets. Following the on-line search, students should develop sketches for a studio project in which they create their own woodcut prints.

The following Internet addresses are good starting points for such a project.

Allan Memorial Art Museum, Oberlin College
http://www.oberlin.edu/allenart
Several *ukiyo-e* prints are presented. Short descriptions are given alongside images. Users can enlarge prints to enhance viewing.

Anne Gary Pannel Center, Sweet Briar College, Virginia
http://www.artgallery.sbc.edu/ukiyoe/collection.html
Prints from the exhibition "Representations of Women" can be viewed at this site. The on-line exhibit is accompanied by short essays and focuses on the portrayal of women in *ukiyo-e* prints.

The Japan Ukiyo-e Museum
http://www.cjn.or.jp/ukiyo-e/arts-index.html
The Japan Ukiyo-e Museum has a number of woodblock prints by various artists such as Hiroshige, Hokusai, and Utamaro.

Kimball Art Museum, Fort Worth, Texas
http://www.kimbellart.org/exhibitions/past_japanese.cfm
This site has five images of woodblock prints from a 1996 exhibit that explored representations of courtesans in Japanese popular culture.

Introduction to Asian Art, Department of Art History, The University of Pittsburgh
http://www.pitt.edu/~asian
An on-line course that includes a detailed segment on Japanese art with an emphasis on *ukiyo-e* prints. Extensive background information as well as images and references are provided.

Evaluation Rubric for Student Internet Research

Evaluated Area	Excellent	Average	Poor
Content	Obtained detailed and in-depth information about the artworks. Discovered in-depth material about the artists. Found very good image to download; wrote a good paper.	Obtained good information about artists. Selected images are good. Obtained some information about artworks. Found an image to download and wrote something about it.	Obtained superficial information. Does not have a downloaded image.
Internet Experience	Searched many web sites. Evaluated all web sites and indicated their validity. Gave a detailed log of Web addresses.	Searched several web sites. Evaluated some of the web sites; indicated validity of web sites.	Used only two web sites. Did not evaluate web sites; gave no indication that web sites used were valid.

Objectives for lessons such as those on Thiebaud and Hokusai might include:

- Students search for web sites that have pertinent information.
- Students develop a database of artists and artworks.
- Students obtain information not presented in class.
- Students download one image of their choice. They study the image and write a short paper discussing the artwork as related to the lesson's concepts.

Evaluation Rubric for Student Internet Research
Evaluating student Web research can be a challenge. However, assessment of computer research need not be different from other classwork. A rubric can be developed like the one on page 82.[9]

Conclusion
The Internet offers art teachers a chance to study numerous art museum collections in the classroom. By incorporating museum web sites in teaching, educators give students the opportunity to view and discuss art from around the world. As technology becomes increasingly integral to our lives, it is imperative for students (and teachers) to critically evaluate electronic data and become savvy consumers of art information on the Internet. Finally, as part of their ongoing investigation of the role of museums in presenting and preserving culture, students can explore the implications of the information superhighway for museums and their collections.

Notes
1 Lois Swan Jones, *Art Information on the Internet.* Phoenix, AZ: Oryx Press, 1999.
2 J. Dobrzynski, "Treasures Are Cloistered But Still on View," *The New York Times*, p. G8, May 21, 1998.
3 J. L. Watson, "Students' Art Goes High-tech," *Journal World*, p. 4, May 5, 1998.
4 L. A. Quinlan, "Creating a Classroom Kaleidoscope with the World Wide Web," *Educational Technology*, 37(3), 15–22, 1997.
5 Lois Swan Jones, *Art Information on the Internet.* Phoenix, AZ: Oryx Press, 1999; G. L Wilkinson, L. T. Bennett, and K.V. Oliver, "Evaluation Criteria and Indicators of Quality for Internet Resources," *Educational Technology*, 37(3), 52–58, 1997.
6 For a complete look at relevant web sites, see *Art Information on the Internet* by Lois Swan Jones.
7 *Le Louvre: Collections and Palace* CD-ROM. Paris, France: Montparnasse Multimedia/Réunion des Musées Nationaux, 1997.
8 Alfred Barr, *Matisse: His Art and His Public.* New York: The Museum of Modern Art, 1951; F. Brill, *Matisse.* New York: Hamlyn Publishing Group, 1969.
9 Eileen Giuffre Cotton, *The Online Classroom: Teaching with the Internet.* Bloomington, IN: EDINFO Press, 1998.

The History Museum and
the Art Curriculum

As we have seen, the art museum offers wonderful opportunities for students to view, respond to, and study works of art from all over the world. Making use of these resources, however, may not always be convenient or feasible. The resources of local history museums represent another teaching option.

Small towns often have historical societies or museums devoted to the acquisition and preservation of artifacts from the area. These collections provide a close look at the way people lived, including the arts and crafts that they produced. By taking the time to review the holdings of a local history museum, you may be surprised to discover a wide range of possible connections to your art curriculum. You may even use the resources of both art and history museums to help students appreciate the differences and similarities between the two settings. This chapter will look at ways to incorporate artifacts and information from history museums into art education instruction.

Discussion Point

Is a Chair a Work of Art?

Galen Cranz, author of *The Chair,* wrote the following:

You may easily forgive chairs for relegating comfort to second place, particularly if you have special fondness for art and beauty. After all, a chair can be viewed as a work of art. Forget class, social superiority, authority, and distinction. Enter line, proportion, shape, materials, decoration, and craftsmanship—all criteria for appreciating chairs as craft, as sculpture, as pure form.[1]

- How can a chair be a work of art?

- Is a chair sculpture?

- Compare and contrast a mass-produced chair with a handcrafted one. What are the important differences, if any?

Discussion Point

Is a Furniture Maker a Craftsperson or an Artist?

Furniture makers consider the design elements in their work such as line, color, texture, and form. They also seriously consider the materials they employ as well as the proposed use of the finished chairs. John Goddard was an eighteenth-century furniture maker in Newport, Rhode Island.[2] He and his family produced elegant pieces of furniture, which often are considered the standard against which other furniture is compared. Can a furniture maker be considered an artist? Why or why not?

Why the History Museum?

What does the history museum offer the art teacher? At its best, these institutions—which represent the ideas, experiences, and events of a community—can provide a bridge between art and students' lives. Teachers can use the contents of a history museum to encourage students to think more deeply about art in general and about the role that art plays in their own lives and homes. Elegantly crafted chairs, exquisitely carved canes, a carefully stitched sampler on homespun cotton, and an early explorer's illustrated journal are all examples of artistic and material treasures found in many history museums.

Students can look at objects found in their community and articulate and argue important aesthetic issues. For example, students could identify the reasons why a piece of folk art is of equal value to a Victorian piece of jewelry. Or, they might explore why it is important to preserve architectural sites in their city. An exposure to local institutions may also encourage students to develop a clearer sense of how to make decisions that range from the appearance of their own homes to issues involved in town planning. Unlike many art museums, history museums have an added benefit of presenting handmade objects within the broader context of a community's history.

A History Museum's Offerings

The primary goal of history museums is to educate visitors about the past. Their artifacts tell the stories of families, communities, cities, states, and even regions. A history museum may house portraits of local community members as well as paintings, photographs, and maps of the community and landscape as it was in the past. It is not unusual to find that a collection includes fine prints including lithographs, woodcuts, and engravings. These artifacts and many others offer students the opportunity to

examine concepts typically considered important in an art education curriculum. Students can investigate the artistic processes, compositional characteristics, and aesthetic qualities of artifacts. They can also discover what these artworks communicate, how they fit into the history of their community, and their artistic value.

Utilizing this type of resource may permit the discussion of issues not usually addressed. For instance, the artists represented in historical collections are, for the most part, locally or regionally important. Therefore, history museums will have works of lesser-known and self-taught artists whose careers may be atypical compared to those individuals commonly highlighted in art teaching.

These artifacts can also broaden discussions about the importance of art in people's lives. Art museum collections are generally viewed with little or no connection to donors and patrons. By contrast, the history museum, because it focuses on a community's past, presents information about artifacts and previous owners. This allows us to look at reasons why people collected objects for their homes or community.

Collections also often include furniture, ceramics, silver, glassware, clothing, and toys. These items may exemplify sophisticated design and construction, or they may represent simple personal creations. Such decorative and functional items offer art teachers and students a way to discuss the purposes that art fulfills in a society, and to examine design elements and principles. Whether sophisticated or simple, such items also may prompt discussions of craftsmanship, the use of materials and tools, the development of craft traditions, and related social issues.

The objects typically found in history museums inherently offer art educators many excellent chances to make connections to social studies, literature, and other subjects. Documents such as maps,

Did You Know?

The Fairfield Historical Society's collection located in Fairfield, Connecticut, encompasses the work of the accomplished printmaker John Taylor Arms, a trained architect, who devoted a considerable portion of his career to the creation of etchings and other types of prints.[3] The museum owns, as well, the photographs of Mabel Osgood Wright, a nineteenth-century author, whose interest revolved around nature and the surrounding environment. She created photogravure prints, collodion prints, hand-colored glass slides, and other historic formats. At the turn of the twentieth century, her interest (like that of other amateur and semi-professional women photographers) was seen as an acceptable undertaking for a woman.[4]

Did You Know?

Connecticut's Mystic Seaport Museum holds an extensive archive from photographers Morris Rosenfeld and Sons—nearly one million images. Rosenfeld was a famous sea photographer who documented such events as the America's Cup races. The museum also has ship portraits in oil and watercolor, carvings, figureheads, scrimshaw, and models of ships.

The Kendall Whaling Museum in Sharon, Massachusetts, has the works of artists who depicted various aspects of sea life. For example, the museum has a painting by William John Huggins (1781–1845), a British artist who was an accomplished ship portraitist and painter of naval life. He learned to draw ships as a young seaman. In 1834, he was appointed as the special Marine Painter to King William IV.[5]

- Why might an individual become a painter of the seafaring lifestyle?

- What kinds of hardship might an individual have experienced in the nineteenth century in order to successfully paint life at sea?

- Why do you think that some artists concentrate on a certain subjects, such as portraits or landscapes?

- What do you think might be more challenging— being a painter of maritime life, landscapes, or still-life? Explain your opinion.

correspondence, illustrations, journals, and contracts may record and reflect intriguing details of everyday life or even aspects of significant historic events.

While historical collections offer art education content, they can also be a source of instructional inspiration. A single visit by a teacher might inspire an interesting and exciting unit or spawn a new way of teaching a lesson. For instance, a collection of glassware, furniture, or quilts may support a lesson on aesthetics. A collection of antique kitchen utensils or farm equipment might be ideal subjects for a drawing or still-life lesson.

Since history museums often represent the ideas of people from a single community, they also may prompt a comparison between local historic aesthetic issues with those of another time, place, or culture. Collections vary greatly; the mission of an individual history museum will determine its perspective, which may range from a focus on a specific local family to the evolution of a region. One institution may have an extensive collection of Chinese ceramics, while another may display fine examples of Art Deco furnishings. Whatever its focus, the history museum is almost sure to offer educational material that is both fascinating and relevant.

Locating Treasures Large and Small

If such historical collections are an important source of artifacts and information, how can they be located? One of the most important ways to identify their presence in a community is to contact a chamber of commerce or other agency whose mission it is to provide information about local places of interest. Such organizations may employ a staffperson who can provide assistance. Another way to discover local historical collections is to get in touch with state historical societies. They typically have a wealth of material concerning statewide collections, and can

direct teachers to accessible sites and sources of information. Other ways to find out about local history museums include perusing travel guides or researching on the Internet. Numerous institutions have web sites designed to inform visitors about their resources and artifacts, as well as practical information such as addresses, hours of operation, and fees.

Learning More About Specific Historical Artifacts

In general, history museum collections tend to include the works of lesser-known artists and craftspeople. Teachers who wish to use such objects may naturally want to find out more about the people who made them. Yet, uncovering additional information can prove difficult and time consuming—sometimes even impossible.

Try This

Photograph collections often represent the evolution of a community at the same time that they record the development of photography. For example, the Newport Historical Society has an extensive collection that encompasses historic formats such as daguerreotypes, albumen prints, paper prints (created through different printing processes), and others. Have students look at early photographs to discover conventions, lighting, background, gesture, pose, and the inclusion of symbolic material. Students also might use old photographs to note how a community has changed over time. Identify and talk about any local artist(s) whose works might highlight these changes. Encourage students to create works (perhaps on site) in which they depict the community as it is now.

6.1 A museum's architecture can provide interesting historical information. Noted architect James Renwick, Jr. designed the Smithsonian buildings to convey the idea of scholarly work and activities. James Renwick, Smithsonian Institute, *1849. Washington, DC. Photo: Davis Art Slides.*

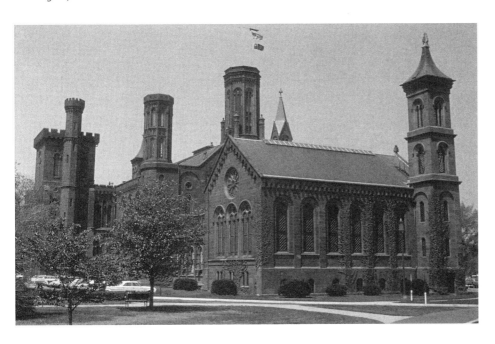

Try This

Many history museums collect photographs of early architecture including private homes, businesses, and churches. The museums can often provide written information and reproductions to help viewers identify architectural styles and understand related historical facts. They also may offer brochures outlining self-guided walking tours. Do the following:

• For some communities, photographs are the only remnants of old downtown areas. Have students study downtown buildings or photographs and compare them to the architecture of contemporary malls and shopping centers. Which do they find more interesting and aesthetically pleasing? Why? They also might argue whether or not a building can be considered a work of art.

• Take students to a neighborhood with historic architecture. Have them take photographs of various examples. Students' photographs can be used to examine local architectural styles and their distinctive elements. Students might develop an exhibit of their photographs that includes researched information.

• Create a class map of your community's center or downtown. Begin by assigning students one building to study and sketch. Students can use photographs (possibly their own), newspapers, or historical material for their work. These sketches are then used to develop a watercolor painting of the area, which becomes part of the class map. Groups of students work to configure the map, deciding on placement of buildings, which landscape features to include, and the labeling of streets and points of interest. The final product might be presented to the chamber of commerce or a local history museum in an effort to earn funds for the art program.

If little or no information about a specific object is available, you might be able to gather material about other works by the artist (or school), or information about the history and use of the type of artifact. You also might compare and contrast the work to similar pieces created by other artists from the same time period. When the artist is unknown, you might study the work for its media, distinctive properties, subject matter, and symbols (especially the importance of symbols in relation to the time when the work was created). Even a simple, brief description of the work can be useful. Such descriptions might include the work's dimensions and approximate date or stylistic period as well as information about the artist's use of line, color, space, composition, and technique. Students might develop interpretations based on such an examination.

Art Education Instruction and Historical Artifacts

How can a teacher use artifacts from a history museum? The most important consideration is the art curriculum. Certain concepts—such as the function, aesthetic characteristics, process of creation, and cultural context of objects—can be used to identify curricular material. The table on page 119 of the Appendix identifies some lesson ideas based upon historical artifacts that are typical of history museum collections. It is important to note that the objects listed here represent only a small sampling of those you might use. The lesson ideas are general and can be modified more specifically to fit both the art curriculum and those items available to you in a local museum.

Furniture design as a general topic has great potential for interesting art lessons, and the chair, in particular, offers some exciting opportunities. To begin a lesson you might look at chair design, period

styles, designer artists, and aesthetic issues. History museums often display pieces of furniture from different periods, which could prompt a comparison of various chairs. Students might also examine examples of chairs from depictions in paintings, drawings, or sculptures. Learners could even consider today's chair designs, their meanings, and related aesthetic issues. They could begin to consider the kind of personality that a chair conveys. Finally, students can design their own chair, perhaps even one that expresses their individuality and functions as a kind of self-portrait.

Another art form with an extensive history is quilting. There are numerous types of quilts, including autograph quilts, friendship quilts, and freedom quilts. Commemorative quilts often include dates, symbols reflecting an event, flags, and other visual information relevant to the quilt's purpose.[6] A lesson built around a single quilt or a series of quilts could touch on art criticism, aesthetics, and the history of quiltmaking. It could end with a studio project in which students design a quilt or work together to create one. Students might each identify one event that was important to them during the school year to depict in one square for a class quilt.

As you consider specific historical artifacts, the curricular connections may be readily apparent. Your resources, time allocation, instructional needs, and availability of materials may all help to determine how an artifact is utilized and to what extent. A historical artifact may inspire a lesson, or it may be an example used in general instruction.

The important point to remember is that pieces from history museums can easily dovetail with the art curriculum—the challenge is to tease out the relationship. You might even allow students to become participants in this process. Exploring how pieces from a history museum might relate to a class-

Try This

History museum collections often include portraits of famous individuals, local families, cultural groups, school classes, etc. Study the postures, clothing, placement, background, and other details of these images. Discuss what these communicate about individuals and their relationships. You also might compare photographic and painted portraits.

Students can then take family pictures that record special celebrations or events. Their collected work might form an album or display that celebrates diversity in the community. Or you might provide students with disposable cameras and have them take portraits of each other that attempt to reveal the personality of the sitter. If possible, make available props, costumes, and various background options.

room topic can provide them with an opportunity to think deeply about art.

Sample Lessons

The material presented below represents instruction that can be linked to historical artifacts—specifically, the lessons on shoes, maps, and photographs. These types of objects are typically found in collections of history museums and can lead to interesting curricular materials. "A Walking Tour of Lawrence" is a lesson on architecture that was based on information available from a history museum.

History museums often have records of local architectural styles that reveal the story behind the homes and public buildings of a town. Such records can be invaluable in tracing the decision-making processes that lead to the evolution of a neighborhood or community. All these lessons can easily be adapted to suit specific needs; they also can be amplified and used in combination with history or social studies classes.

Lesson Title: Shoes Tell a Story
Level: Middle School

Context and Overview

In this three-part lesson, students study examples of shoes from different periods of history. They consider the materials used to construct the shoes as well as the lifestyle, gender, and values of the people who wore them. Students will also look at the work of shoe designers and think about shoes as works of art. The final part of the lesson engages students in a studio project that entails designing a shoe according to a "shoe scenario." The scenarios are vignettes from the history of shoes accompanied by criteria for the project.[7]

Objectives

Students will:

- be knowledgeable about shoes and how they differ due to lifestyle choices, values, and fashion trends.
- organize a select number of shoes according to a timeline, taking into consideration materials and design.
- design a shoe, taking into account specified criteria and historical information given in class.

Instructional Strategies

Part One

1. Students discuss reproductions of different contemporary shoes. Topics include: Why were these materials used? What differences exist between men's and women's shoes? What values are communicated about the role of men and women? What might it be like to walk in these shoes? Students select a shoe they find interesting and speculate about the lifestyle of a potential owner.

6.2 Christopher Melanson, age 13, creating a shoe based on a scenario.

2. The class views reproductions of ancient Roman and Greek shoes and discusses style, materials, and possible uses. Small groups receive an assortment of five reproductions of shoes from various historical periods. Learners identify the shoes' place in history, possible functions, and the values they represent. The class discusses group findings.

Part Two

Each student chooses a shoe scenario for the design of a shoe. They must consider the criteria provided as well as information concerning the history of shoes presented in class. Sample scenarios[8] include:

- Shoes throughout history reflect individuals' activities, status, and preoccupations. Design a shoe destined to be worn at a certain location, such as the beach, the library, a music concert, or an art museum.
- Pointy-toed shoes became popular around the fourteenth century and the fashion spread throughout Europe and beyond. Sometimes the points were so long that they had to be tied up to keep them from dragging. Make a shoe that reflects a popular fashion trend today.
- There is evidence that ancient people commissioned burial shoes. These functioned as status symbols for the next world. Create a shoe for a deceased artist whose works you admire.
- After having gone out of fashion for almost 1000 years, the sandal made a comeback in the 1920s. With the addition of heels, sandals were glamorous again. Create a sandal that would dazzle even the most bored individual.
- Red heels, a status symbol in seventeenth- and eighteenth-century Europe, were worn only by the privileged classes. Design a shoe that clearly displays your hopes and dreams, be they trips to the moon or elsewhere.

Studio Tips

Students do not draw the shoe; they simply work with a painted shoe provided by the teacher. You can obtain shoes from a thrift shop at low cost, or ask parents to furnish old shoes. The shoes are spray-painted white so students have essentially similar starting points from which to begin the project.

6.3 This project, based on a shoe scenario, was designed to symbolize the creator's interest in aviation.

Part Three
Provide students with a selection of old shoes that have been spray-painted white. Students create their own design by affixing a variety of materials to a shoe. They can even heighten and lengthen the shoes with wood scraps. Decorative details might be created with plastic foam, beads, sequins, colored wire, and tempera paint. Students can write a label explaining how their shoe design reflects the scenario they chose.

Assessment Strategies
1. During class discussions, notice the quality of students' contributions and how they justify their speculations concerning shoes, shoe styles, trends in fashion, and values associated with them.
2. While students organize shoes according to time periods, note the reasons for their classification.
3. Students should critique their own shoe designs according to criteria provided.

Lesson Title: Maps as a Reflection of Ourselves[9]
Level: Upper Elementary

Context and Overview:
In this lesson, students learn about the different purposes that maps can fulfill, the kinds of information that they communicate, and the symbols and other methods through which they convey information. Learners examine a variety of maps from ancient to contemporary formats, and identify their special features, imagery, and symbols. Ultimately, the lesson communicates that maps are culturally derived and reflect those who create them. Students create a map that reflects a personal experience.

6.4 *Shoe created for Jacques Cousteau by Douglas Catloth, Olathe, Kansas.*

Objectives

Students will:

- examine and discuss different types of maps, concentrating on special features, the type of information communicated, and symbols and imagery.
- describe map features. One way to accomplish this is to have them complete a worksheet. Side one could ask for descriptions of the map features, focusing their examination on a map's colors, border, title, and location. Students also consider any animals, objects, or symbols depicted on the map. On side two, students describe a trip they took, or an adventure they had.
- create a map using tempera paints and large format paper. The map details an experience described on side two of the worksheet. It should incorporate three characteristics from maps examined during class.

Instructional Strategies

1. Give an overview of maps, why they are useful, and the variety of types. Begin the lesson with questions, such as: How can maps help us? What kind of imagery is included on a map? What types of maps exist? Where do we usually encounter maps? Who creates them? Explain that maps can help us to find our way. Maps also provide us with a way to visualize a place. They can give a place personality by the inclusion of details, imagery, and other visual information.

2. Have groups of three examine a map. They complete side one of the worksheet. Student responses are discussed with the whole class.

3. Assign students to complete the second side of the worksheet.

4. Demonstrate painting techniques that will be used as part of the project. Techniques include

Try This

Have students research local culture by studying artifacts such as quilts, pottery, and jewelry. They should develop a file of material about artifacts, festivals, and exhibits obtained from newspaper articles and other sources. Students can interview local artists to supplement their file. Finally, they gather images of artifacts or take photographs of them. Guide students to look at their gathered materials collectively or individually, and determine what examples might be important to collect for preserving or understanding local culture. Discuss the role of the museum in relation to this issue as well as the idea of acquiring artifacts, caring for them, and exhibiting them.

Try This

Explorers, whether at sea or on land, often keep journals of their travels and discoveries. Some history museums have logs or other manuscripts of this type. Even the least artistic individuals often sketched or painted what they encountered during such expeditions. Have students keep a journal for ten days. They should write entries and draw some of the experiences they have, including the things and people they see. Inform students that they are to consider everything with fresh eyes, as if seeing for the first time. Learners could pretend that they are from another time or place. You might even develop a pool of fictitious personalities or situations to engage students.

dry brush, crayon resist, solid painting, and stippling.

5. Students design a map of their own with the following criteria:
- It uses three characteristics of the maps examined.
- It includes two of the demonstrated painting techniques.
- It reflects one of the experiences listed on the worksheet.

Assessment Strategies

1. Review worksheets for completeness and comprehension.
2. Examine maps in relation to the inclusion of information such as symbols and images.
3. Have students critique their own maps according to criteria provided.

Lesson Title: Walking Tour of Old West Lawrence
Level: High School

Context and Overview

This two-part lesson highlights a historical section of Lawrence, Kansas. This material represents the type of information that history museums offer concerning the buildings that exist in many cities and towns throughout the country. Old West Lawrence, listed on the National Register of Historic Places, includes 126 historic homes. A community museum's background facts served as the foundation for the lesson. The teacher provides an overview of the architectural styles represented in the neighborhood, including Victorian, Queen Anne, Italianate, Craftsman, Tudor, Colonial Revival, Prairie, and Shingle styles. In Part One, the teacher gives students background information. In Part Two of the lesson, students view the historic style examples as part of a walking tour.

Objectives

Students will
- be knowledgeable about different house styles, their characteristics, and origins.
- tour an area to see examples of the architectural styles studied in class.
- complete a worksheet based on their walking tour. The worksheet requires them to identify and discuss the styles observed.

Instructional Strategies

Part One

1. Ask students to think about the styles of architecture that are represented in the town of Lawrence. Students speculate and consider the history of the town, possible influences, and the kinds of materials used to build homes. The discussion becomes more focused as the questions and dialogue center around Old West Lawrence.
2. Students view a set of slides of architectural styles of Old West Lawrence homes. Each style is discussed; information is given about origins and cultural influences.
3. Small groups of students are given a reproduction of a house style. They are to discuss the style in terms of the lifestyle it represents as well as the aesthetic characteristics and the architectural elements represented.

Part Two

1. Students visit Old West Lawrence and complete a worksheet that requires them to identify architectural styles observed. They discuss the distinguishing characteristics of these styles and compare and contrast certain examples of architecture.
2. Students select one home to sketch as part of the worksheet. The sketch accompanies a final

research report on historical background and stylistic characteristics of their chosen home.

Assessment Strategies
1. Note the quality of student comments and questions during the class discussion of architectural styles.
2. Student worksheets can be used to identify the information provided and judge the accuracy of this material.
3. Examine the final research report for completeness and quality of information.

Lesson Title: Old Photographs: Snapshots in Time[10]
Level: High School

Context and Overview
Prior to the lesson, students discuss the various functions and meanings of a photograph, including preservation of a moment in time; a record of a person, place, or event; and as a work of fine art. For this two-part lesson, students are given the opportunity to examine older photographs in an effort to learn how to carefully read them so as to develop interpretations concerning their meaning. The activities will allow students to investigate anonymous as well as archived photographs in the collection of a history museum. The lesson is designed to refine students' skills in reading and understanding photographic images.

Objectives
Students will:
- learn how to decode photographs by concentrating on their content and characteristics.
- answer questions about certain photographs and write "stories" of individuals portrayed in them.

Try This

Until the last century, most wooden sailing vessels had figureheads at their bow carved by ship carvers who were regarded as artists.[11] These bow decorations are carved figures of men or women, brightly painted, and often larger than life. They represented the personality and soul of a ship not just for its owners, but also for those on land. Often, figureheads were the only remnants that washed ashore when ships sank or were stranded. Figureheads were created to survive the harsh weather conditions of the sea; they were often designed with hands close to the body in an effort to prevent deterioration. In some cases, arms were not included.

- Figureheads have not traditionally been considered works of art. In fact, figureheads are not discussed in books on sculpture. Many other carved works from the same era are regarded as art.

- Provide students with reproductions of figureheads. Lead a discussion of whether students think figureheads are works of art. Students also can develop an argument in a written essay. Or, they might research figureheads and develop a classroom display.

- Bring in photos of car hood ornaments and have students compare them to ships' figureheads. They could look at the function and form of each type of decoration and discuss how the objects might represent the "personality" of a ship or car. Have them create an ornament for a vehicle. Students should take into consideration wear, function, and aesthetic appeal.

- be knowledgeable about the photographs in a local history museum, their role in depicting the past, and how they provide valuable information.
- apply previously learned skills to identify and interpret the subject matter of selected archived photographs.
- develop a report that incorporates their examination of photographs, including short stories and their final conclusions concerning archived photos.

Instructional Strategies

Part One

1. Students examine and study old anonymous photographs (perhaps collected over time from flea markets and garage sales). Explain to students that archaeologists dig up artifacts to discover clues about a culture or time period. Students are asked to be archaeologists by researching details within a selected photo.
2. Students write "stories" about the people within the image. These stories can be based on what they see and what they know about the time periods as well as questions such as: "Who is the individual(s) in this image?" "Where was the photo taken?" "What are the circumstances behind this photo?" and "Why might this photo have been created?" Students summarize what they have found and present conclusions as part of a report to be completed during the next part of the lesson.

Part Two

1. Students apply their skills from Part One to a museum collection of photographs. This offers students a unique opportunity to develop their skills to a higher level. Students follow the same research strategies, but instead of using anonymous photos, they use archived images. Their detective work can then be tested through accessing museum information about the images. A museum relies on the clues uncovered by asking questions as in #2 above to create a better understanding of the past. Students become aware of the importance of the role of the visual image in recreating history.
2. Students develop a preliminary interpretation based on their visual examination. The initial interpretation is later expanded or modified with research.
3. Students verify their visual research by comparing their findings to available information on the photos.
4. Students compile their information from Part One of the lesson into a more extensive report that presents their conclusions concerning archived photographs.

Related Activities

Students can consider issues related to the critical realm of photography. Questions might include: Why is photo quality important to one's research? How can we be sure that written information about a photo is correct? How much do we rely on photos for historical data? What elements in the photos you examined were the most important for your research? Students can also consider aesthetic questions, such as: Do we tend to read a photo as being completely truthful? How has digital imaging affected this truth? When is photography art? Should photos such as these be placed in a history museum or an art museum? Why?

Assessment Strategies

1. Students should document all facts used to determine their conclusions. A source list will be collected.
2. Collect and review students' reports at the end of both phases of the research process.
3. Students write a comparison of the preliminary interpretations and actual facts concerning examined archived photographs.

Conclusion

As students investigate the documents and objects in a local history museum, they will gain insights about the aesthetic and other values held throughout past years in their community. Students also may gain a better understanding of themselves as members of this community—especially how their own values and choices are influenced by those who have come before them. These experiences with the collections of local history museums can also help students make links between their personal lives and the works of art and artifacts that they will encounter through the art curriculum, in museums, and in their everyday experiences.

Notes

1 Galen Cranz, *The Chair*. New York: W. W. Norton, 1998, p. 65.

2 Newport History. *Newport Historical Society*, 69 (239 & 240), 1998.

3 E. E. Endslow, *Fairfield Printmaker John Taylor Arms: Visions of Home and Abroad*. Fairfield, CT: Fairfield Historical Society, 1997.

4 R. L. Abbott, *The Friend of Nature: Mabel Osgood Wright*. Fairfield, CT: Fairfield Historical Society, 1998–99.

5 The Kendall Whaling Museum, 1999. http://www.kwm.org/collections.

6 Patsy Orlofsky, *Quilts in America*. St. Louis: McGraw-Hill, 1978.

7 D. Stone and E. Kowalchuk, "Shoes Tell a Story." Unpublished lesson taught at The University of Kansas, Lawrence, KS, 1999. (Based on historical information found in works by Kaufman and Hewlett, O'Keeffe and Bleckmann.)

8 Lois L. Kaufman and R. Hewlett, *If the Shoe Fits*. New York: Peter Pauper Press, 1998; Linda O'Keeffe and Andreas Bleckmann, *Shoes: A Celebration of Pumps, Sandals, Slippers and More*. New York: Workman Publishing, 1996.

9 E. Kowalchuk, "Maps as a Reflection of Ourselves." Unpublished lesson taught at The University of Kansas, Lawrence, KS, 1999.

10 A. Perkins, "Old Photographs: Snapshots in Time." Unpublished lesson taught at Lawrence High School, Lawrence, KS, 1999.

11 H. J. Hanson and C. B. Hansen, *Ships' Figureheads*. West Chester, PA: Schiffer Publishing, 1990.

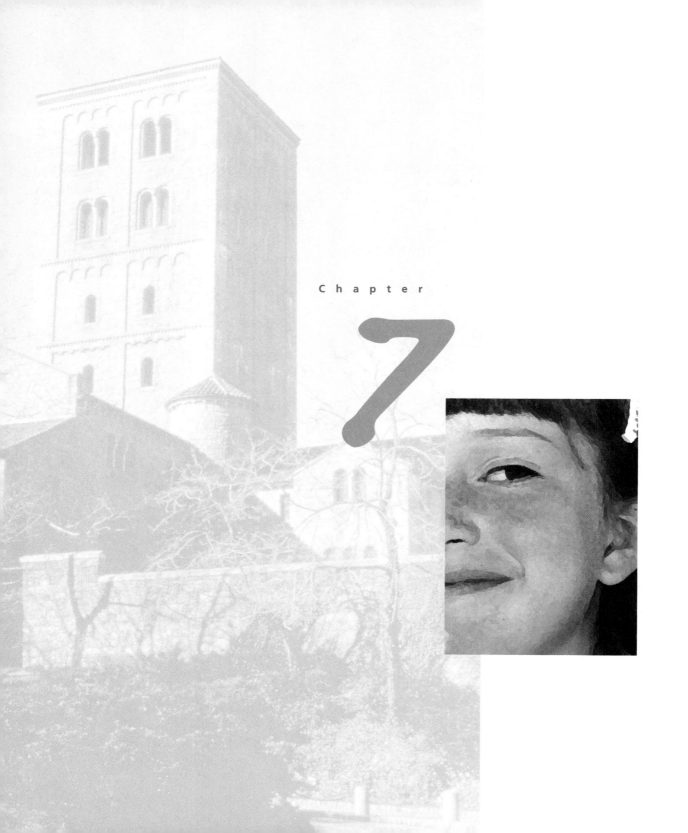

Chapter

7

Promoting the Art Museum

Art teachers are in an excellent position to educate colleagues and administrators about what art museums have to offer. Most classroom teachers and administrators have little idea about how the art museum relates to school education. In addition to integrating art and art museums into classroom instruction, teachers can help students and their families discover possibilities for involvement with art on their own through relevant museum programs and activities. Many parents are unaware that art museums offer a special setting to share information and experiences with their children.

The following sections provide a framework of ideas for advocating some of these resources. Numerous examples outline the type of information about museums that art teachers can offer. Of course, these are only examples. In certain cases it will be appropriate to share these specific examples with students, parents, and administrators. In other instances, you must work to uncover information about similar programs and offerings in your own community.

Art-Making at a Museum

Students and even their families might spend time in an art museum sketching or painting the pieces on view. Many artists have spent time in their early careers copying famous works as a way to learn important artistic skills. Renoir is one excellent example; he visited the Louvre on numerous occasions to study the paintings of artists such Delacroix, Watteau, Boucher, Fragonard, and others.[1] In fact, he began this practice at the age of fifteen. Students might explore how copying can lead to inspiration and ideas for their own original artistic work. Such projects can also concentrate on a skill or technique such as perspective, realism, or contour line drawing.

Art Museum Collections and Visitors' Experiences

Art museum collections have the potential of affecting visitors in different ways. Robert Motherwell, a famous painter, thought it was important for museums to concentrate on numerous pieces of artists' works. He said the following: "Perhaps the most remarkable experience that I have had of a museum was in the new Léger Museum in the south of France, at Biot, not because it was devoted to Léger, but because its hundred of works by him show the whole working life of an artist of stature. There one can have the sense, the real sense, of just what Léger was, just by looking, just by looking in one place. What a joy!"[2]

Stress the Importance of the Museum

The following quotations are from artists who have expressed their thoughts about the importance of art museums. You may share such information with students in class or with teachers, administrators, and family members through announcements or any form of correspondence or public display.

As a child, Robert Kushner spent a lot of time in art museums with his mother, a practicing artist. He attributes his career in art to these childhood experiences. Kushner said the following about these early museum visits:

"Being a serious artist marooned in suburbia, my mother would frequently see exhibitions at the Los Angeles County Museum of Art, the Pasadena Art Museum, and the small group of commercial galleries in Los Angeles at the time. I often went with her but found much of the advanced work that was of interest to her too hard to understand, and I gravitated to the historical work that was also shown. But just being in the museums and seeing beautiful things was an important part of my childhood. I would often come home and try to copy what I had seen."[3]

The famed Louvre in Paris is just one of the many art museums that have inspired artists and would-be artists for generations. Paul Cézanne wrote:

"The Louvre is the book in which we learn to read."[4]

Of the same museum, Henri Matisse wrote:

"I have always maintained one foot in the Louvre, so that, even when going forth adventuring, I always have anchor in the native land."[5]

The well-known painter Elizabeth Murray was once an art student at the School of the Art Institute of Chicago. Because the school was associated with a museum, Murray could frequently visit the galleries to view artworks. She has spoken of the powerful influ-

ence museum visits had on her career and her work. In fact, she was greatly affected by a Cézanne painting, *The Basket of Apples*, that is part of the permanent collection at the Art Institute. Murray says:

"In retrospect, it's quite an unremarkable painting except for some beautiful *petits fours* which are stacked like tiny logs. But for some reason, that painting was the first in which I lost myself looking. I had seen it almost every morning and every afternoon for a year, but suddenly I really looked at it and understood what art was. It sounds religious, but it is not the same thing as having a revelation. It's very quiet. I just realized I could be a painter if I wanted to try. Before that experience, I thought artists were like Picasso or Michelangelo; they didn't have any reality to me. That understanding came later."[6]

The artist Richard Hamilton, famous for his contributions to the British Pop Art movement, also attributes his appreciation of art to his museum experiences. Hamilton says:

"Even before I was a student at the Royal Academy, I spent a lot of time in the print room at the Victoria and Albert Museum, looking at etchings. At that time I could hardly distinguish between Frank Brangwyn and Rembrandt, but I immersed myself in those prints, and I came to know a great deal about them and how they were made…My love of art was inculcated by free access to museums such as the Tate Gallery and the Victoria and Albert Museum. I used to spend time every weekend in those places."[7]

As you come across such pertinent quotations, add them to your file of advocacy materials. Share them as often as possible. Particular phrases or stories may resonate with different personalities at your school or in your community.

Become Familiar with Local Offerings

In order for art teachers to successfully promote and partner with art museums, they must be knowledgeable about the offerings at local institutions. Today's museums offer a wide variety of programs. This section offers some examples of programs specifically geared to families, youths, and teens. They are meant to give the reader an idea of the kinds of things to look for in his or her community.

Again, educators may rely on a number of different methods for communicating such information, including postings in class and around school, notes sent home, and even announcements on school web sites. Students may also create their own public awareness announcements to disseminate and publicize this information.

Family Programs

Museum family programs offer comparatively low cost and even free events that give family members the chance to learn together—whether to appreciate or to make art. By making students aware of these offerings, teachers can also encourage students' families to attend. Family programs encompass gallery experiences, such as tours, storytelling, games, films, and hunts, as well as activities such as dancing, theater, and musical performances. These programs are often accompanied by hands-on studio activities; such activities may focus on two- or three-dimensional work ranging from masks and clay projects to printmaking, painting, and drawing.

Museums regularly change and rotate family programs contingent upon special exhibits, holidays, institutional events, and local cultural celebrations. Frequency and type of services, fee requirements, and age restrictions differ from one museum to another. A good number of institutions have activities for parents on a weekly or monthly basis, during

Not Your Typical Museum Exhibit

Guillaume Bijl is an installation artist who lives in Antwerp, Belgium. Bijl is known for transforming museum spaces.[8] He has, for example, turned gallery and museum spaces into a driving school, a nuclear bomb shelter, and a physical fitness center. Viewers see these spaces and the objects in them differently in a museum than they would in reality. The artist said, "A museum transforms things into works of art. A museum is, in this sense, a crucial space for me. It's one of the spaces I like most to be in, it's one of the spaces which concerns me most. As an artist, it's a central part of my life."

7.1 Maquettes of Henry Moore's sculptures at the Nelson-Atkins Museum of Art afford students a unique perspective on the artist's work. Art teacher: Elizabeth Hatchett.

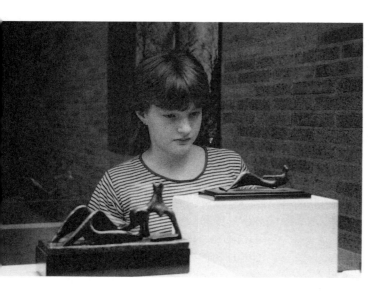

weekends, and with or without pre-registration. Some museums may even provide elementary and secondary students with family passes. Institutions often furnish families with self-guided tour materials that allow them to visit galleries at their own pace.

The following are a few examples of the variety of family program offerings at art museums. The Minneapolis Institute of Arts offered a Family Day, "Celebrating Asia," to celebrate the grand opening of the Asian gallery. One in a series of their monthly family offerings, this day provided performances of Chinese dancing, Japanese Taiko drumming, Chinese lute, and the traditional Chinese Lion Dance. Opportunities to participate in a treasure hunt and to make a hanging scroll rounded out the day.[9]

The Museum of Fine Arts in Houston has family days on Sunday with a new focus each month.[10] The museum's "Creation Station" offers Sunday afternoon drop-in workshops for families. These workshops cover different types of studio activities.

The de Young Museum in San Francisco has dedicated "Gallery 1" to families and children. The gallery is equipped with a computer and reading area. Activities are designed to facilitate the appreciation of works on view from the permanent collection.[11]

When families are unable to attend museum events, art teachers might play a role in providing assistance—for example, by helping to sponsor families for a visit through fundraising events or by engaging the support of the PTA. An art club also might bring together interested students and their families, thus serving as a catalyst for organizing museum visits. Finally, consider incorporating the content of family programs into your art curriculum. The integration of these ideas and concepts can further serve to interest students in family programs, while providing a chance to teach new material in the art classroom.

Youth Programs

Art museums provide services for students outside traditional school programs. These include, but are not limited to, high school level art history courses, children's studio workshops and classes, and special teen programs. Advanced placement courses can be particularly valuable for high school students interested in furthering their art history education. Encourage students to look into these options, and provide guidance to interested students by obtaining relevant information.

Children's art classes, available year round at many institutions, relate studio experiences to museum collections. Classes may concentrate on certain media, art forms, or themes. Elementary children are the usual target audience for these classes. Inform students about these and similar experiences by discussing them in class or through announcements and postings.

Teen Programs

Museums around the country offer a wide range of programs specifically geared to teenagers. These teen programs may involve high school students in leading gallery tours (for peers, younger children, or the general public), giving classroom presentations, contributing to family day activities and children's studio classes, and even helping with office tasks in various museum departments. Some programs do not allow students to teach, and museum work may be limited to general duties or assisting in classes. A number of art museums have programs that involve high school students either as volunteers or as paid employees.

In general, teen programs usually require students to give a minimum number of hours to the museum on a weekly, monthly, or yearly basis. They often require an application procedure, which may or may not involve a formal interview. Inform students about such offerings, and help to guide them through the process. Eligibility requirements may state that students show an interest in museum work, art, or the humanities as well as have certain computer and communication skills. Participation usually involves a training period during which time students may learn about a museum's collection or a special exhibit, practice touring techniques, and become familiar with the behind-the-scenes operation of an institution.

Actual responsibilities vary from museum to museum, and not all institutions offer teen programs. Developing and implementing them requires sufficient resources and staff to select, organize, train, and supervise students. And in order for a teen program to realize positive results, museums usually must orchestrate arrangements with a school. There are, however, many successful teen programs throughout the country. The following are only a few examples.

Since 1982, the Fine Arts Museums of San Francisco, which encompasses the de Young Museum and the Legion of Honor, has invited high school students to participate in the Museum Ambassador Program.[12] This year-round program pays teens to teach. Training introduces participants to the art they will present, public speaking and teaching techniques, and the museum. Ambassadors give presentations mostly to younger children from third to fifth grades, but they also provide instruction to older adults. Additionally, students visit libraries, day camps, and clubs. Museum Ambassadors teach a sizable audience of 9000 each year, which contributes to the museum's goal of exposing more San Franciscans to art. For the 1997–98 school year, students taught children and adults about the art of West and Central Africa.

Corporate Collections

The Donald Kendall Sculpture Garden in Purchase, New York, is owned by PepsiCo Inc.[13] The collection includes forty-two large outdoor sculptures, including works by Alexander Calder, Henry Moore, Claes Oldenburg, Louise Nevelson, David Smith, Jacques Lipchitz, Auguste Rodin, Joan Miró, Giacometti, Max Ernst, Tony Smith, and George Segal. The sculptures are located on a 114-acre garden, which is open and free to the public.

7.2 Consideration of aesthetic issues regarding modern art was one aspect of a visit to the Nelson-Atkins Museum of Art. Art teacher: Larry Percy.

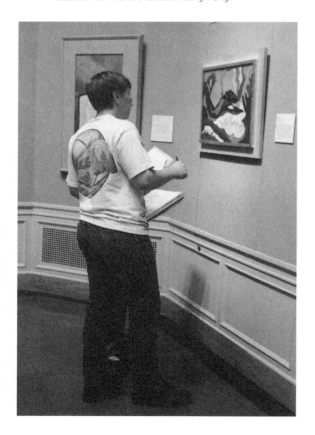

The Indianapolis Museum of Art established the Community Connection Outreach Program in 1993. This program exposes African-American high school students to various museum career opportunities.[14] Students are drawn from public schools, churches, and educationally focused organizations. They receive intensive training about the museum's collection and special exhibits. Community Connection students lead mini-tours, make presentations at various statewide sites, work as museum ambassadors during various museum events, and participate in both distance learning and the development of educational videos. In 1996, Community Connection students studied the general history and culture of Egypt in anticipation of a special exhibit titled "The American Discovery of Ancient Egypt." Students traveled to thirty Indiana sites to give team presentations to a variety of audiences.

The Nelson-Atkins Museum of Art offers a summer Teen Tour Guide Program. This program involves high school students in teaching children, ages 8–12, about sculptures in both the Kansas City Sculpture Park and the museum's collection of modern and contemporary works.[15] The program evolved as a result of the museum's successful relationship with the Paseo Academy of Visual and Performing Arts High School. Students receive training at their high school and at the museum, and the content of the teen program meshes with students' art curriculum. During the summer of 1998, Teen Tour Guides focused on sculptures including Ursula von Rydingsvard's large scale works located in the park surrounding the museum and in the galleries.

The Walker Art Center provides a number of vehicles for teens to become involved in the museum.[16] A Teen Arts Council makes contemporary art and artists accessible to a diverse group of teenagers in the area. The council works with the museum's

staff to develop and market teen-specific programs. The Teen Arts Council produces a quarterly publication titled *Fig. 12*. It features information about the Walker and community programs of interest to teenagers, as well as examples of teen writing and visual art. Other opportunities include residency projects with artists, internships, tour-guiding experience, free gallery admissions, and student memberships. The Walker attempts to offer 14- to 18-year-old students links to contemporary art and artists, the chance to safely ask questions, and ways to express themselves.

Collect Museum Facts

In order to promote the art museum, teachers should be on the lookout for information about the institutions in their communities. For example, art museums often have libraries with invaluable materials that can include catalogs, magazines, books, rare books, monographs, and other types of materials for study.[17] The National Gallery of Art in Washington has 20,000 volumes on art and art history, along with many other valuable documents. These library materials allow art experts to research the collection as well as art from other museums. The National Gallery's collection even includes Leonardo's treatise on painting titled *Trattato della Pittura*. Teachers might send this kind of information home with students as part of a packet about "visiting the art museum with your child."

Another good example is the Frederic Remington Art Museum in Ogdensburg, New York. Established in 1923 to house and exhibit the artist's works for whom it was named, the permanent collection consists primarily of Remington's paintings, bronzes, watercolors, drawings, photographs, letters, and personal art collection.[18] The museum also has a reconstruction of the artist's last studio, equipped with the original furnishings.

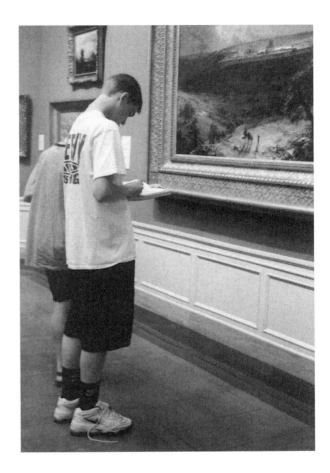

7.3 Gallery worksheets encouraged students to carefully study, analyze, and interpret paintings at the Nelson-Atkins Museum of Art, Kansas City, Missouri. Art teacher: Larry Percy.

Educators might include descriptions of various local institutions that specialize in collecting and preserving a certain type of art, such as portraits. The following are just a few such examples.[19]

- The Oriental Institute in Chicago contains the archaeology and art of the ancient Near East with a collection that includes artifacts found through excavations in Egypt, Turkey, Syria, Iran, Iraq, and Israel. Displays include sculptures, a fragment of the Dead Sea Scrolls, Egyptian mummies, and other objects.
- The Textile Museum in Washington, D.C., has a collection of textile arts. Works include handmade artifacts such as carpets, blankets, saddle covers, and clothing from countries such as China, Egypt, Persia, Africa, India, Indonesia, and Spain.
- The Corning Museum of Glass in Corning, New York, has a collection of 25,000 objects. The artifacts represent all periods of the history of glass from 1500 B.C. to the present.

Educators also might conduct research to find examples of nontraditional or other unusual local art museums. The following, for example, are descriptions of museums that do not use buildings to house their collections.[20]

- The Museum of Outdoor Arts in Englewood, Colorado, displays artwork outside. Families can picnic at the site, walk around, and enjoy what they see. The museum features architecture, landscape, and large scale sculptures as well as smaller works made of stone, bronze, and clay.
- Laumeier Sculpture Park just outside St. Louis, Missouri, is a ninety-six-acre park with a collection of contemporary sculpture by internationally known artists. The outdoor sculptures are part of a natural setting of trees, woodlands, and hiking trails. Visitors can walk around the sculptures and experience the three-dimensional quality of the works while enjoying the out-of-doors. An affiliated museum houses changing exhibitions of contemporary art and special exhibitions.
- The Storm King Art Center in Mountainville, New York, just north of New York City, has a permanent collection of more than 120 large scale sculptures on 500 acres of land. The collection includes works by David Smith, Henry Moore, Alexander Calder, Andy Goldsworthy, Richard Serra, Isamu Noguchi, Magdalena Abakanowicz, Siah Armajani, Mark di Suvero, Louise Nevelson, and others. The Storm King Art Center grounds consist of rolling hills, fields, and woodland areas. Families can stroll throughout the premises and an indoor museum. (Picnics are confined to a particular area.)

Look for Additional Resources

Educators do not necessarily have to create their own forms of communication to get the message across to teachers, administrators, and families. In addition to having students help uncover such information, art teachers can rely on a variety of existing forms such as books, poems, CD-ROMs, and videos. Here are a few examples to get you started.

Visiting the Art Museum is a book appropriate for teachers and families of elementary students.[21] The book describes a family visit to a museum relayed in a humorous manner. This title might be used as a vehicle to promote the idea of a museum as a place for families to enjoy themselves and learn at the same time. Another book is *The Nine-Ton Cat: Behind the Scenes at an Art Museum* by Peggy Thomson and Barbara Moore.[22] This title provides interesting behind-the-scenes information about a day in the life of the National Gallery of Art. It is most appropriate for upper elementary and middle school students. Included is a discussion of the intricacies of

Chapter 7

planning an exhibit from placement of art, lighting design, and the color of gallery walls to the use of maquettes to determine the best displays.

The following poem by Ruby Lewitt, titled "Where the Paintings Live," is a possible resource for helping communicate information to other teachers and to families of elementary students. The poem, for example, might help generate a discussion about a museum's value to a community and its role in safekeeping artworks.

"Where the Paintings Live"
 by Ruby Lewitt

Where the paintings live,
hung on the walls in frames of gold,
you can see anything,
from modern times to days of old.

Where the paintings live,
a gigantic and special place,
you can see anything—
a beautiful portrait, a lop-sided face.

Where the paintings live,
each room holds a new surprise,
you can see anything,
from swirling storms to a bright sunrise.

Where the paintings live,
quiet, cool, whispering halls,
you can see anything,
like napping cats on garden walls.

Where the paintings live,
and statues in each corner play,
you can see anything
maybe even MY art someday![23]

The video *From the Mixed-Up Files of Mrs. Basil E. Frankweiler* is an appropriate resource for teachers and families of third and fourth graders.[24] It is a mystery about the maker of a sculpture donated to the Metropolitan Museum of Art by a rich patron. The story is based on a book by the same title, which is suited to intermediate readers. Portions of the video highlight the role of the museum in researching and caring for works.

Conclusion
As we have seen, art teachers have a variety of means to help them become advocates of art museum and museum programs. As a result of participation in such offerings, students, other teachers, administrators, and even family members will develop a deeper appreciation of and interest in art. And at the same time that their participation expands their knowledge base, students' experiences may assist them in developing communication and leadership skills. Those involved in teen programs also may have the chance to earn stipends, high school credit, or scholarships. Such involvement may prompt students to take college courses in the arts and may even inspire some to pursue professional careers within the art world.

Notes

1 Lawrence Hanson, *Renoir: The Man, the Painter, and His World*. New York: Dodd, Mead & Company, 1968.

2 Stephanie Terenzio, *The Collected Writings of Robert Motherwell*. New York: Oxford University Press, 1992.

3 G. Sizemore, "Mothers, Mentors, Mischief: What Makes a Child Want to Be an Artist?" *ARTnews*, 95(1), 110-113, 1996.

4 D. W. La Cour, *Artists In Quotations*. Jefferson, NC: McFarland & Company, 1989, p. 159.

5 La Cour, p. 86.

6 Sue Graze, *Elizabeth Murray: Paintings and Drawings*. New York: Harry N. Abrams, 1987, p. 122.

7 R. Hamilton, "My Love of Art Came from Museums," *ArtInternational*, 10, 1990. p. 51–52.

8 G. Bijl, "Museums Are Crucial for Me as an Artist," *ArtInternational*, 10,53, 1990.

9 The Minneapolis Institute of Arts, 1998. Educational programs. http://www.artsmia.org

10 Museum of Fine Arts, Houston,1998. Programs for families. http://www. mfah.org

11 de Young Museum. Gallery activities for families, 1998. htttp://www.thinker.org.

12 Brown, T. "Kids as Constituents," *Museum News*, 69(5) 72-74, 1990; Fine Arts Museums, 1998. Museum ambassador program. (Available from the Fine Arts Museums of San Francisco, California Palace of the Legion of Honor, M. H. de Young Memorial Museum, Golden Gate Park, 75 Tea Garden Drive, San Francisco, CA 94118-4501)

13 *American Art Directory 1997–1998*. New Providence, New Jersey: R. R. Bowker, 1997.

14 Indianapolis Museum of Art, 1998. Community connection outreach program. (Available from the Indianapolis Museum of Art, 1200 West 38th Street, Indianapolis, IN 46208-4196)

15 Nelson-Atkins Museum of Art, 1998. Teen tour guide program at the Nelson-Atkins Museum of Art. (Available from the Nelson-Atkins Museum of Art, 4525 Oak Street, Kansas City, MO 64111)

16 The Walker Art Center, 1998. Walker Art Center teen programs. (Available from the Walker Art Center, Vinland Place, Minneapolis, MN 55403)

17 Peggy Thomson, *The Nine-Ton Cat: Behind the Scenes at an Art Museum*. Boston: Houghton Mifflin, 1997.

18 *American Art Directory 1997–1998*.

19 *The Official Museum Directory*. Washington, DC: American Association of Museums, 1997.

20 *The Official Museum Directory*.

21 Laurene Krasny Brown, *Visiting the Art Museum*. New York: Dutton, 1986.

22 Peggy Thomson, *The Nine-Ton Cat*.

23 B. B. Walmsley and A. M. Camp, "Primary Theme Club." *Instructor*, 106 (8), pp. 25-31), 1997.

24 Hallmark Home Entertainment, 1995. *From the Mixed-Up Files of Mrs. Basil E. Frankweiler*. (Available from Hallmark Home Entertainment, 6100 Wilshire Blvd., Suite 1111, Los Angeles, CA 90048)

Appendix

Note to teachers: Worksheets and Checklists in this Appendix are designed for you to copy and use in your classroom. For best results, you may want to enlarge them when copying.

Museum Visit Planning Checklist

Make the necessary arrangements by contacting the museum education staff:

Museum _____
Date called _____
Contact person _____
Phone/e-mail _____
Details of arranged visit:

To do:
Class schedule change(s)

Transportation arrangements

Chaperones (name, address, telephone)
1. _____
2. _____
3. _____
4. _____
5. _____
6. _____

Lunch or snack plans, if relevant

Other task(s)

Identify the art to be viewed:

Identify objective(s) for the museum visit:

❑ Explore the collection in relationship to the curriculum
❑ Examine a historical period reflected in the collection
❑ Investigate how the museum's collection reflects the history of art
❑ Study several artists' works included in the curriculum
❑ Introduce/reinforce new art forms
❑ Introduce/reinforce new cultures
❑ Other (specify)

Indicate students' previous museum experience(s).
have visited the museum:
❑ none ❑ some ❑ often
have visited other art museums:
❑ none ❑ some ❑ often
have visited other types of museums:
❑ none ❑ some ❑ often

Ideas for orienting students to the museum:

List one or two lesson ideas for preparing class.
(Examples: Art-historical information about artists, periods, or styles; a studio project based on techniques to be studied at museum; and criticism activities in which students describe works similar to those at museum.)

1. _____

2. _____

Inform students about the purpose of the trip:

❑ This trip will introduce new art forms/cultures.
❑ This trip will expand knowledge about art and artists we have studied.

Identify method(s) of evaluating students' museum learning:

❑ Quiz based on museum tour information
❑ Essays in which students apply formal analysis to one or two works
❑ Museum worksheet incorporating several objectives of visit
❑ Student writing samples about artists' works, including interpretative statements
❑ Other (specify) _____

Checklist for Incorporating Museum Visits into the Classroom

Identify resources for reviewing and extending museum visit concepts:

❏ Museum catalog(s)
❏ Videos
❏ Books
❏ Reproductions

Select possible objective(s) for classroom integration:

❏ Explore one or several artists' works seen at the museum

❏ Examine one artist's career and body of work

❏ Investigate an art movement and its place in art history

❏ Study a theme (e.g., landscapes by artists in the collection)

❏ Conduct in-depth research of cultural artifact(s) in the collection

❏ Examine artists' sources of inspiration reflected in museum works

❏ Introduce new studio techniques observed in artists' works

❏ Study how the museum's collection reflects the history of art

❏ Other (specify)

Plan a studio project idea for extending learning (explore new media, techniques, subject matter, etc.).

Plan an art history, art criticism, or aesthetics lesson based on museum learning (conduct research, create a timeline of art, write interpretations, plan research paper, etc.).

Identify way(s) to evaluate students' learning:

❏ Research paper on an artist's work seen during museum visit

❏ Research project, such as an art history timeline of the collection

❏ Students' written responses to art seen at the museum

❏ Short quiz

❏ Studio project

❏ Other (specify)

Hypothetical Art Curriculum with Integration of the Museum

Lesson Ideas with Key Concepts

Focus	Studio Projects		Aesthetics Content		Art History Content		Criticism Content	
	Lesson Example	Museum Connection	Lesson Example	Museum Connection	Lesson Example	Museum Connection	Lesson Example	Museum Connection
Artistic Process: Print-making	Students learn about the printmaking process and create prints with Käthe Kollwitz as an example of a master printmaker.	Museums use dimmed lights to display prints. This helps preserve and protect them. Why? Experiment: expose paper and wood to natural lights.	Prints are often less expensive than paintings. Discuss the difference between a painting and a print. Is one more valuable than the other?	Museums have different editions of prints. Are they equal in value and as art? Discuss two different prints by Albrecht Dürer, their location and value.	Study the work of Mary Cassatt, who was inspired by Japanese woodblock prints. Explore depiction of subject matter.	Museums display many examples of prints. Why is this important for a museum and for the viewer? Develop a display of prints with a focus.	Read a review concerning the work of contemporary artists (i.e., Jaune Quick-To-See Smith). Students decide whether they agree or disagree.	Museum staff who are trained as art historians investigate artists' works. Locate a museum catalog and identify information relevant to critics.
Theme: Nature	Georgia O'Keeffe interpreted the scenery near her home (*The Mountain, New Mexico*, 1931, Whitney Museum of Art). Students use surrounding sources for their landscapes.	Actual works have unique characteristics different from reproductions. What might be noticed about O'Keeffe's watercolors if viewed in person?	Stuart Davis' landscapes and Red Grooms' cityscapes show different artistic concerns. Compare and contrast. Is one artist's subject or approach more valid than the other? Why?	Discuss why museums would collect art like Alma Thomas' *Red Azaleas Singing and Dancing Rock and Roll*, which is located at the National Museum of American Art.	Artists have created landscapes throughout history. Why? Students examine several works from three periods and speculate.	Large museums such as the Metropolitan Museum of Art in New York City have numerous landscapes by various artists. Why can this kind of museum afford to do this?	Students compare and contrast the work of Winslow Homer and Jennie Augusta Brownscombe. They interpret the artists' works in an essay.	Art critics review special museum exhibits. Locate an article concerning a recent exhibit and have students examine the issues discussed.
Style/Period: Pop Art	Students study Wayne Thiebaud's paintings of food items, shoes, and various objects. They create an artwork that exemplifies some of the artist's concerns.	Wayne Thiebaud's thickly applied paint was achieved through certain techniques. Sensitize students to reproductions and originals. Students create paintings, photograph them, and compare.	Beginning in 1962, Andy Warhol's paintings were executed by assistants, who would photograph his work, manipulate the colors, and screenprint the images. Who should be credited, the artist or his assistants?	Claes Oldenburg created *Shuttlecocks* for the Nelson-Atkins Museum of Art. It prompted a local controversy. Have students study the issues and argue for and against certain positions.	Pop artists' works have much to say about our society. Study Andy Warhol, Wayne Thiebaud, and Claes Oldenburg. Compare and contrast each.	Commercial galleries exhibit artists' works. The Campbell-Thiebaud Gallery in San Francisco features Wayne Thiebaud's art. Compare and contrast the commercial gallery with the art museum.	Have students select one Pop artist: Andy Warhol, Wayne Thiebaud, or Claes Oldenburg. Students develop a statement about the meaning of the artist's work.	Have students create a "museum" that displays Pop artists' works. Students' interpretive statements are used as labels. Identify critics who review the "special exhibit" and have students assess critics' reviews.

Dimensions of the Art Museum

	Museum Collections	History of Museums	Museum Functions	Benefactors	Museum Architecture	Artists
Description	Facts about collections, history, location, recent acquisitions, deaccessions.	Early development of museum including figures, events, politics, and the relationship of this history to current displays.	Collecting, preserving, exhibiting, and educating.	Individuals who support the museum.	Museum building as art.	Their relationship to the museum.
Content	Different types of collections have certain focuses—sculpture gardens, single artists' works, encyclopedic collections, and so on.	Early contributors, early and current focus of collection, early and current directors, and so on.	Museum staff make decisions about what and how art is placed in galleries. Curators create exhibits, develop labels for the displays, and write catalogs providing information about art.	Individuals contribute money, private collections, personal time, and professional expertise to the museum. They often donate monies and solicit contributions from communities.	Museum architecture reflects the wishes and values of museum staff, benefactors, architects, and others.	Artists develop various kinds of ties to museums for different reasons.
Some Museum Examples	The Salvador Dali Museum in St. Petersburg, Florida, concentrates exclusively on the artist's work and can be considered a single-artist museum.	The Isabella Stewart Gardner Museum in Boston, Massachusetts, was designed by Isabella herself to house her collection. The museum at one time served as her private home. The display of works is still dictated by her will.	The Corcoran Gallery of Art was recently given a Picasso—a still life titled *A Glass on a Table*. It is the first Picasso painting in the collection. It was put on display alongside a Picasso etching, *The Frugal Repast*.	Werner Kramarsky, a New Yorker, has collected art since 1958. His 2500 drawings cover Pop Art to post-Minimalist works. He plans to bequeath his collection to the Museum of Modern Art and Harvard's Fogg Art Museum.	The National Gallery of Art's East Wing was designed by I. M. Pei who has also designed an addition to the Museum of Fine Arts, Boston, the Louvre, and the campus museum at Indiana University.	Georgia O'Keeffe, the sole inheritor and executor of Alfred Stieglitz's estate, gave the Art Institute of Chicago a substantial number of Stieglitz's works. The museum had provided O'Keeffe with her first museum retrospective.
Lesson Ideas	Have students study a folk artist's work (i.e., *Garden of Eden* in Lucas, Kansas). Students consider the work as a collection and compare/contrast it to a museum. They examine when a museum becomes a museum and identify reasons.	Divide students into two groups. Assign roles for director and board of trustees. Groups identify the art for their museum, create a display with reproductions exemplifying respective philosophies, and discuss museums' future collections.	Students create a class art museum. They organize their own artwork based on museum displays and develop labels. Students play the role of museum staff: director, curator, guard, etc., and tour visitors.	Students identify favorite artists, "shop" for art (reproductions), and pay undisclosed amounts for them. They select at least ten for a personal collection, decide on a museum recipient, and discuss reasons.	Students discuss their idea of an art museum and develop sketches for their community museum reflecting local ideas and available cultural artifacts.	When studying an artist, note the collections that include his/her work and locate cities on a map. Ask students how artworks find their way to museums all over the world. How can we see them in spite of distance? Is this positive or negative?

Label Writing Worksheet

Student Name _____

Object Identification:

Artist _____

Title _____

Type of object _____

Medium/materials

Date of execution _____

Country of origin _____

Owner _____

Object Description
Provide a brief description, paying attention to size, color, texture, and so on. Be sure to mention parts of the object that the viewer should notice and why.

Interpretation
To help viewers understand the piece, briefly discuss the meaning and purpose of the object, providing insights into the use of colors, inclusion of symbols, and other important details.

Considerations for Computer-Based Instructions

Incorporating the computer in art education instruction is fun and exciting. However, there are some important concerns to take into account related to censorship and student safety on the Internet. An Acceptable Use Policy (AUP) can help teach expected behaviors for computer-based teaching. Further, an AUP can assure parents of appropriate instructional goals and objectives. For an in-depth discussion about the need for an AUP, please refer to Eileen Giuffre Cotton's *The Online Classroom: Teaching with the Internet* (1998), published by EDINFO Press. The author gives an example of an AUP as well as Web addresses for additional information.

--

Worksheet
Exploring a Museum on the Web

1. Museum _____

 Country _____

 Internet address _____

2. Describe the collection.

3. Name one artist whose works are part of the collection. List the title of his/her work. Download an image of his/her work and describe its visual characteristics.

4. Do you think the museum is large or small? Explain.

5. Would you visit this museum in person? Explain.

Identifying Art Museum Web Site Resources

Art Museum _____

Location _____

Web Address _____

Date Visited _____

Scope of Collection
Web Site Contains:

Artists	Period	Art Forms
_____	_____	_____
_____	_____	_____
_____	_____	_____
_____	_____	_____
_____	_____	_____
_____	_____	_____
_____	_____	_____
_____	_____	_____
_____	_____	_____
_____	_____	_____
_____	_____	_____

❑ Fast links
❑ Links to other good sites
❑ Virtual tours
❑ Virtual exhibits
❑ Information about on-line exhibits
❑ Data base of images
❑ On-line activities and games for students
❑ Useful images that can be quickly downloaded
❑ Contextual information—artists and artworks
❑ Teacher materials

❑ Information about catalogs and related publications
❑ Offers interaction and participation
❑ Access to library and archives
❑ Search engine
❑ Background and history of the museum and collection
❑ Other

Curricular Approach for a Sampling of Historical Artifacts

Art Education Focus	Furniture (Chair)	Painted Portrait	Photographic Portrait	Quilt	Native Pottery
Key Idea	The chair, in existence for five millennia, has expressed social class, image, and moods, as well as communicated different messages of power and authority.	During the early 1800s in New England, itinerant artists produced artisan portraits of middle-class citizens. These portraits reflected the culture, role, and life of the sitter, as well as his/her social class.	Portraiture is an important category in photography. The amateur as well as the professional seeks to capture the likeness of individuals.	Commemorative quilts were used to note events of national importance. Examples include the ratification of a state, a historical celebration, or the election of a president.	Pueblo potters were inspired by their culture—the environment, nature, and spiritual values provided a source of images and pottery designs.
Function	Unlike other pieces of furniture, the chair can serve to relay importance and status as well as to provide comfort and for other purposes.	Artisan portraits served to document family members, celebrate achievements, or demonstrate prosperity.	Photographs of people provide a visual record of them as well as an interpretation of their personality.	The quilts symbolized an individual's likeness as well as memorialized certain events and battles.	Pottery was used for food preparation, storage, and rituals.
Cultural Content	A photographer or portrait painter will seat sitters in special chairs to express an aspect of an individual's personality or to show the whole person.	Itinerant artists, self-taught artisans, traveled through towns to obtain commissions. Resulting portraits shared certain similarities in their inclusion of details, style of depiction, and price.	Photography, although a relatively recent development, has provided many with the ability to depict relatives, friends, politicians, and others.	Quilts reflect the history of the country, including the values quiltmakers held about certain political events and social issues.	Clay deposits determined the availability of different pottery ware. Traditions of making pottery were carried from one generation to another.
Aesthetic Considerations	The design of a chair—the lines of the legs, seat, and back as well as the materials used to create it—determines its look and image.	Because they were primarily self-taught, itinerant artists produced works that were markedly different from others created by academically trained artists.	The lighting, the sitter's attire, posture, and expression all reveal the subject's physical attributes and personality. It also conveys the truth of the photographer, his/her vision of what can be revealed.	Commemorative quilts often included flags, the likeness of political heroes, banners, handkerchiefs, and symbols.	The forms and design of Pueblo pottery are reflective of traditions and function, as well as values concerning nature.
Lesson Idea	Students examine hand-crafted chairs and illustrations of chairs from various historical periods. They will develop a self-portrait in the form of a chair, incorporating features and elements studied.	Students create a portrait that reflects the occupation, interest, culture, and personality of the portrayed individual. Learners can include furniture, accessories, natural scenery, and other details to reveal the person's life.	Learners examine several examples of professional portraits. They develop a portrait for a magazine of a popular or important figure that must express his/her significance and personality.	Provide several examples of commemorative quilts and lead a discussion about aesthetic elements of each. Students select one event in the school year they will portray for a class quilt.	Learners create a container using a hand building and/or pottery wheel-throwing technique that reflects their life and culture.

Books Related to Art Museums

Young Readers

Björk, C., and Anderson, L. *Linnea in Monet's Garden.* Stockholm, Sweden: Rabén & Sjögren Publishers, 1987.

Linnea, a young girl, travels to Giverny with Mr. Bloom, her neighbor, to visit Monet's garden, now a museum open to the public. She learns about Impressionism, Monet, his family, home, and garden, and a number of paintings. The book is peppered with reproductions, photographs, and explanations of Monet's works, his flowers, and family. The most obvious use for the book is as a vehicle to teach about the artist, his style, and life. Another use would be as a resource about a different kind of museum—one created by the artist.

Brown, L. K., and Brown, M. *Visiting the Art Museum.* New York: Dutton, 1986.

A family visits the art museum and has an enjoyable experience in spite of the reluctance of some of the children. Everyone learns about the museum and the art. The book includes reproductions of art from all over the world. Additional information about galleries and art is included at the back of this humorous book.

Dickinson, M. *Smudge.* New York: Abbeville, 1987.

Smudge, a young restless boy in a painting, finds his way out of his picture. He roams through museum halls, finding adventure in various parts of the building including the basement where works are repaired. He visits various artworks such as an Egyptian picture, a Greek vase, and a mummy stored in a case. However, his adventures lead him into mischief with the museum guard and figures in the galleries. The story ends quite happily as Smudge discovers a way into a painting, finding a new home with the help of the art repair person.

Goldin, D., and Heckel, I. *A Tale of Two Williams.* New York: Metropolitan Museum of Art, 1977.

William, or Willy as his friends call him, visits the Metropolitan Museum of Art with his mother during the Christmas season. While at the museum shop, Willy comes across a magical creature who lives there, a stuffed blue hippopotamus. Also called William, he takes Willy to visit interesting places at the museum. Finally, the pair finds its way to the Medieval Hall where a very tall Christmas tree

is on display. This is a useful book for explaining to young children that a museum can include unusual objects from armor to period rooms with various types of furnishings.

Hurd, T. *Art Dog.* Harper Collins, 1996.

Arthur Dog is a guard at the Dogopolis Museum of Art where works by Vincent Van Dog, Pablo Poodle, and Leonardo Dog Vinci can be seen. Arthur is the mysterious Art Dog who paints when the moon is full. His art, brushes, and paint help him catch thieves who stole the Mona Woofa.

Lionni, L. *Matthew's Dream.* New York: Alfred A. Knopf, 1991.

Matthew, a mouse, lives in an attic. One day he is visits a museum with his classmates and is taken by the art he sees. He is inspired by the museum experience to become a painter and look at the world in a different way.

Mathers, P. *Victor and Christabel.* New York: Alfred A. Knopf, 1993.

Victor is an art museum guard who is taken with a painting titled *Cousin Christabel on Her Sickbed.* He falls in love with Christabel, who seems sad and lonely. Victor brings her flowers, and the mystery of the painting unfolds to reveal a story of magic, bringing Victor and Christabel together.

Reiner, A. *A Visit to the Art Galaxy.* San Marcos, CA: Green Tiger Press, 1990.

A brother and sister visit a modern art museum with their mother but do so unwillingly. (They would rather play instead.) When they arrive, the children stand in front of one of Rothko's painting and begin to wonder about it. Suddenly, something unusual and exciting transports them to the Land of Modern Art, a place that appears like the sky where they meet artists of all kinds—Matisse, Picasso, and Kline. During their travels, they learn about modern art as well artists' opinions of art.

Stanley, D. *The Gentleman and the Kitchen Maid.* New York: Dial Books for Young Readers, 1994.

Rusty, an art student, visits a room in which two Dutch portraits hang across from each other, *Portrait of a Young Gentleman* and *The Kitchen Maid.* The subjects of these works have fallen in love. One day, Rusty discovers that the museum moved *Portrait of a Young Gentleman* to a

nearby gallery, separating the couple. She finds a way to restore happiness by painting a picture of both.

Simmonds, P. *Lulu and the Flying Babies.* New York: Alfred A. Knopf, 1988.

Lulu visits the art museum with her father, against her wishes. However, as she is displaying her dissatisfaction, she is separated from her father and baby brother. Several angels from art displayed in the gallery help her, also providing a tour of various paintings. She has a delightful time at the museum, reunites with her father, and relays her happy experience.

Zadrzynska, E. *The Peaceable Kingdom*. New York: M. M. Art Books, 1993.

A whimsical story of how three animals from *The Peaceable Kingdom*, the leopard, lion, and a gray wolf, escaped from Edward Hicks' painting at the Brooklyn Museum of Art. Two children and their mother discover the animals in the Brooklyn Botanic Garden; the police, city mayor, and two professors attempt to discover the true home of the animals. Eventually, the children lead all to the Brooklyn Museum.

Intermediate Readers

Cavanna, B. *Mystery in the Museum*. New York: William Morrow & Company, 1972.

Ellen Tate, an art student, works at the Boston Museum of Fine Arts' bookshop. During an opening of a Cézanne exhibit, a valuable and rare antique bracelet is stolen. Through a some unusual events, Ellen finds herself involved in the mystery.

Knapp, R. and Lehmberg, J. *American Art, Off the Wall Museum Guides for Kids*. Worcester, MA: Davis Publications, 1998.

Books in this pocket-sized series can be used either at the museum or in the classroom. They offer many interesting facts, including brief biographies for each painter and tips on how to look at his or her work. Small reproductions give readers a general idea of an artist's style. After a trip to a museum, these books are an effective way to wrap up, with suggestions for activities and compelling marginalia to get students thinking about what they have seen.

Knapp, R. and Lehmberg, J. *Egyptian Art, Off the Wall Museum Guides for Kids*. Worcester, MA: Davis Publications, 1998.

Knapp, R. and Lehmberg, J. *Greek and Roman Art, Off the Wall Museum Guides for Kids*. Worcester, MA: Davis Publications, 2001.

Knapp, R. and Lehmberg, J. *Modern Art, Off the Wall Museum Guides for Kids*. Worcester, MA: Davis Publications, 2001.

Knapp, R. and Lehmberg, J. *Impressionist Art, Off the Wall Museum Guides for Kids*. Worcester, MA: Davis Publications, 1998.

Konisburg, E. L. *From the Mixed-up Files of Mrs. Basil E. Frankweiler*. New York: Dell Publishing, 1987.

Claudia decides to run away from her family, convincing her brother Jamie to join her. They find their way to the Metropolitan Museum of Art, where they take up residence sleeping in the galleries and hiding in the restrooms. Claudia is intrigued by a famous statue donated by a rich benefactor. The statue's maker is unknown, and Claudia decides to try to solve this mystery. She finds the former owner, Mrs. Basil E. Frankweiler, and proceeds to solve the mystery and her family dilemma.

Pickard, N. *A Generous Death*. New York: Pocket Books, 1984.

The Martha Paul Frederick Museum of Fine Art was once the private home of arts benefactor Martha Paul. Leaving her money to the city of Port Frederick for the purchase of art, Martha Paul stipulated one condition: purchased pieces were to be displayed in her former home. The building, however, is in serious disrepair. To complicate matters, the museum is in a financial crisis. Arnie Culverson, a local wealthy eccentric, is found dead in the museum by fourth graders on a field trip. This Jenny Cain mystery has the potential for generating interesting class discussions.

Richardson, J. *Inside the Museum*. New York: The Metropolitan Museum of Art and Harry N. Abrams, 1993.

The book gives an overview of each curatorial collection at The Metropolitan Museum of Art, highlighting works with in-depth facts and interesting tidbits of infor-

mation. It also gives behind-the-scenes views of the museum such as the role of curators, designers, and conservators.

Thomson, P., and Moore, B. *The Nine-Ton Cat: Behind the Scenes at an Art Museum.* Boston: Houghton Mifflin, 1997.
 This informative book about National Gallery of Art operations provides a view of a day in the life of an art museum. The content is rich with information and includes tidbits about individual artworks that are part of the National Gallery's collection. Tasks and responsibilities of curators, conservators, protectors, and others who contribute to the museum are highlighted.

Index

About the Author

Denise Stone teaches art and design education, as well as art museum education, at the University of Kansas in Lawrence. She has published numerous articles concerning art museum education and the relationship between museum educators and teachers. Prior to university teaching, Stone taught art in a variety of districts from inner city schools to rural settings.